"A jewel is eternal. Its precious materials are an extension of the body stimulating harmonious vibrations."
Jean-Pierre De Saedeleer.

THE ART OF EROTIC JEWELLERY

To Diane

CLAUDE MAZLOUM

THE ART OF EROTIC JEWELLERY

In collaboration with:

Paolo SPALLA
Michael ZOBEL
Bernd MUNSTEINER
Enrico PINTO
Jacques MICHEL
Erwin PAULY

Acknowledgements

*The author would like to thank the following for their help: Cellina BARTH,
Silvio BELEKDA, Chantal BIZOT, Pascal BRANDT, Amanda BRESSON, Marisa BRIATA,
Dieter BROTZMANN, Roland CARRERA, Chris COLEMONT, Rosanna COMI,
Edwige DELLA TORRE, Vincent DE JAEGHER, Emile DUFOUR, Guido FIGDOR,
Emile GAUBERT, Jean-Jacques GOLFAR, Jennifer HENRICUS, Günter KRAUSS,
Haidrun KUHLMANN-RIEDASCH, Bruno LIVRELLI, Reinhold LUDWIG, Peter MADDICK,
Philippe MAILLARD, Bernd MEIRERRIEKS, Claudio MILISENDA, Pierre MORGAN,
Wilfried MORLOCK, Béatrice NORMAND, François RENAC, Karen RENDERS,
Heide-M. REINDL-SCHENERING, Jean-Claude SABRIER, Alessandro SERRA, Marcello SERRA,
Armando STADELMANN, W. TOCBOSCH, Guido GIOVANNINI-TORELLI, Maurice TROVAJOLY,
Tomi UNGERER, Daniel VERGÈS-RENAU, Gianni VETRANO, Olga VETRANO,
Gabriele WEINMANN, Alberto ZORZI.*

Italian texts translated by: *Lenore Rosenberg*

Layout: *Fortunato Romani*

Jacket design by: *Antonio Dojmi*

Phototypeset and Photolithography: *Graphic Art 6 s.r.l. - Rome*

Printed and Bound by: *Conti Tipocolor - Calenzano (Florence)*

ISBN 88-7301-053-9

CONTENTS

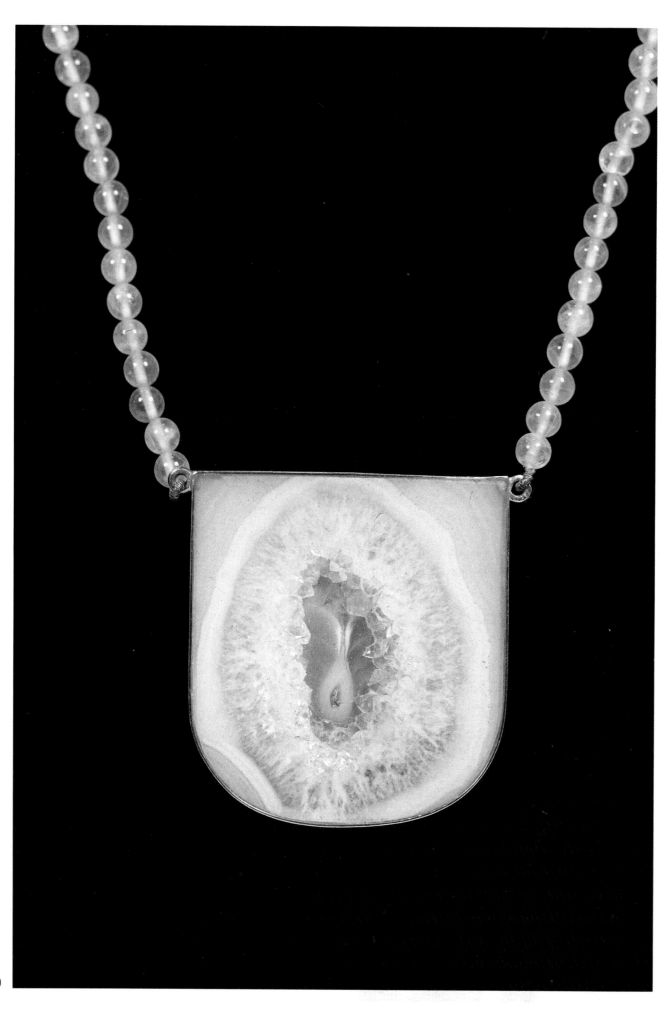

FOREWORD

Women epitomize the most beautiful jewels in the Creation, therefore all of the precious gems found in nature are at a woman's whims. Each glorifies the other's splendour since jewels have the peculiarity of often 'becoming' the woman who wears them, and viceversa. In ancient and modern times, goldsmiths and jewellers have always rendered homage to women and eroticism which is the world's prime mover, in creating treasures focused on this theme.

Continuing his voyage in the realm of jewellery and precious stones, Claude Mazloum presents the readers of this new "Art of Erotic Jewellery" with a highly seductive and stimulating itinerary. To blend gold with eros and gems with sensuality is a millenerian idea, nonetheless Mazloum through his own sensitivity and long-acquired skills of a refined jeweller and a master precious-stone cutter offers a completely new approach with unrivaled equilibrium. The masterpieces of internationally acclaimed creators appearing in this book – each so different from the other yet inspired by the same spirit – represent the optimum achievement in a field where finesse, good taste and fantasy are imperative common denominators.

GUIDO GIOVANNINI-TORELLI
Editor "Diamond Insight", New York

INTRODUCTION

Since the dawn of time, ornaments of the human body have had a primary function: to attract attention and the eye, underlining a form of power.

In eras when clothes were only used to protect skin from the cold, ornaments, apparently useless accessories, sent the community a very clear message. They were emblems of power, wealth and beauty, uniting the three essential conditions of seduction.

There is nothing new under the sun, and if new accessories have supplanted the old throughout the centuries, jewels are still an absolute, incontrovertible sign of nobility, a sparkling rellection of wealth and symbols of beauty and love.

It is just a short step from love to eroticism. That is why in this volume I have decided to bring together two different aspects which are found both in eroticism and jewellery. The first aspect is the desire to attract the

LES BIJOUX

La très chère était nue, et, connaissant mon cœur,
Elle n'avait gardé que ses bijoux sonores,
dont le riche attirail lui donnait l'air vainqueur
Qu'ont dans leurs jours heureux les esclaves des Mores.

Quand il jette en dansant son bruit vif et moqueur,
Ce monde rayonnant de métal et de pierre
Me ravit et m'extase, et j'aime à la fureur
Les choses où le son se mêle à la lumière.

Elle était donc couchée et se laissait aimer,
Et du haut du divan elle souriait d'aise
A mon amour profond et doux comme la mer,
Qui vers elle montait comme vers la falaise.

Les yeux fixés sur moi, comme un tigre dompté,
D'un air vague et rêveur elle essayait des poses,
Et la candeur unie à la lubricité
Donnait un charme neuf à ses métamorphoses;

Et son bras et sa jambe, et sa cuisse et ses reins,
Polis comme de l'huile, onduleux comme un cygne,
Passaient devant mes yeux clairvoyants et sereins;
Et son ventre et ses seins, ces grappes de ma vigne,

S'avançaient, plus câlins que les Anges du mal,
Pour troubler le repos où mon âme était mise,
Et pour la déranger du rocher de cristal
Où, calme et solitaire, elle s'était assise.

Je croyais voir unis par un nouveau dessein
Les hanches de l'Antiope au buste d'un imberbe,
Tant sa taille faisait ressortir son bassin.
Sur ce teint fauve et brun, le fard était superbe!

– Et la lampe s'étant résignée à mourir,
Comme le foyer seul illuminait la chambre,
Chaque fois qu'il poussait un flamboyant soupir,
Il inondait de sang cette peau couleur d'ambre!

Charles Baudelaire, *Les Fleurs du Mal*

partner's gaze towards the body's erogenous zones: in this case the jewellery can take on any form and their glitter is an explicit invitation to act. The second is a figurative or symbolic aspect. The message is more or less in code, an expression of the desire of the wearer.

So, dedicated to the creation of life, this volume excludes vulgar pornography and the more explicitly provocative.

Its pages contain amusing, occasionally "naughty" poetic subtleties, that disclose the spirits of the greatest creators of erotic jewellery.

Created to seduce or to be seduced the jewels shown in these pages always provide an excellent occasion to stimulate our nerve endings. Let's start with the jewels that inspired Baudelaire to write his famous poem.

CLAUDE MAZLOUM

The dearly loved one was nude and, knowing my heart,
Had kept on only her sonorous jewels,
Whose rich appearance gave her that victorious aspect
Of the Moors' slave-girls on their happiest days.

When, dancing, her ironic, lively sounds come forth,
This world radiant with metal and stone
Enraptures me in ecstacy, and I love to madness
Those things where sound is mixed with light.

She lay there then and let herself be loved,
And from the top of the sofa smiled with pleasure
At my love, as deep and as tender as the sea
That washed up to her like up to the rocks.

Her eyes fixed on me, like a tamed tiger,
With a dream-like air she sought a new pose,
And candour along with her lasciviousness
Gave a new charm to her metamorphesis;

And her arm and her leg, her thigh and her back,
Smooth as oil, sinuous as a swan
Moved in front of my eyes, far-seeing, clear;
And her womb and her breasts, grapes in my vineyard,

Protruded endearingly as the angels of evil,
To upset the rest where my soul did lie,
And to distract her from the crystal rock where she sat,
Calm and solitary.

I seem to see in a new design
The hips of Antiope on the bust of a callow youth,
So much in contrast was her tiny waist to her pelvis.
Proud was the beauty on that brown, tawny flesh.

And that the lamp was resigned to death,
And only the hearth lit up the room,
Every time it heaved flaming sigh
It washed blood of that amber-coloured skin.

Paolo Spalla, sculptor and jewel creator in Valenza, Italy.

REPRESENTATIONAL ART

In collaboration with Paolo Spalla

One of Paolo Spalla's primary goals is to communicate through form. Spalla is an artist twice kissed by fortune. First of all, he is endowed with an extraordinary talent for sculpture and then he was born in Valenza, the city of gold and cradle of some of jewellery-making's oldest traditions. He is a foremost example of the jeweller-sculptor. From his earliest youth, Spalla spent most of his time on the banks of the river Po. He cherishes this river with a true lover's passion, finding inspiration in the rotundity, the colours and the gleam of the stones he uses to create jewellery exhibited all over the world. Spalla feels very close nature and to 'his' river. Here he finds the energy he needs to express the symbolism of his work. The Po's mysterious source is for him the symbol of the essence of life, love, movement, air and God – ideals imbedded in the core of his being.

His series entitled "Homage to Woman" is a tribute to life, aimed at highlighting the source of life itself.

Paolo Spalla speaks to us of his concept of the origin of eroticism – one that is successfully retlected in his work.

"Our susceptibility to eroticism might well lie in conception. Perhaps it is because you begin your life in a woman's womb. When you draw your first breath of air from outside, there is a vagina behind you. You really begin life suckling at the breast. When they cleaned you they pulled on your penis, kissed it and warmed it. Unconsciously, that is where you begin. And slowly, as you grow, your curiosity begins. You imagine situations that may be distorted, unrelated to authentic Eros, but

anything and everything helps stimulate your brain. It is important to be free. At the age of five or six you start making friends and living in a group, in tribes, among older children too. You go to the river (the Po) and dressed only in your skin your start experimenting with your body, sharing emotions with a friend or two. At school everyone has a piece of chalk and an overwhelming desire to draw female and male private parts on the walls. Then, with the curiosity of people who know little, you begin stealing a centimetre of skin from the other sex. Your eye skins through a rolled down stocking, a dress that rose up in the wrong place and a leg pedalling a bicycle, and you begin to have morbid daydreams about what you can discover as your make your way up to the centre of the body. You become loaded with memories.

White gold pendant by Paolo Spalla (Private collection).

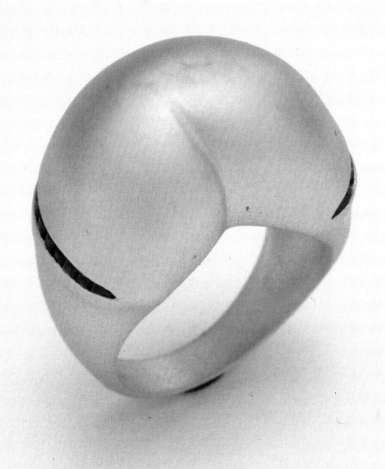

16 *Gold ring with square rubies by Paolo Spalla (Private collection).*

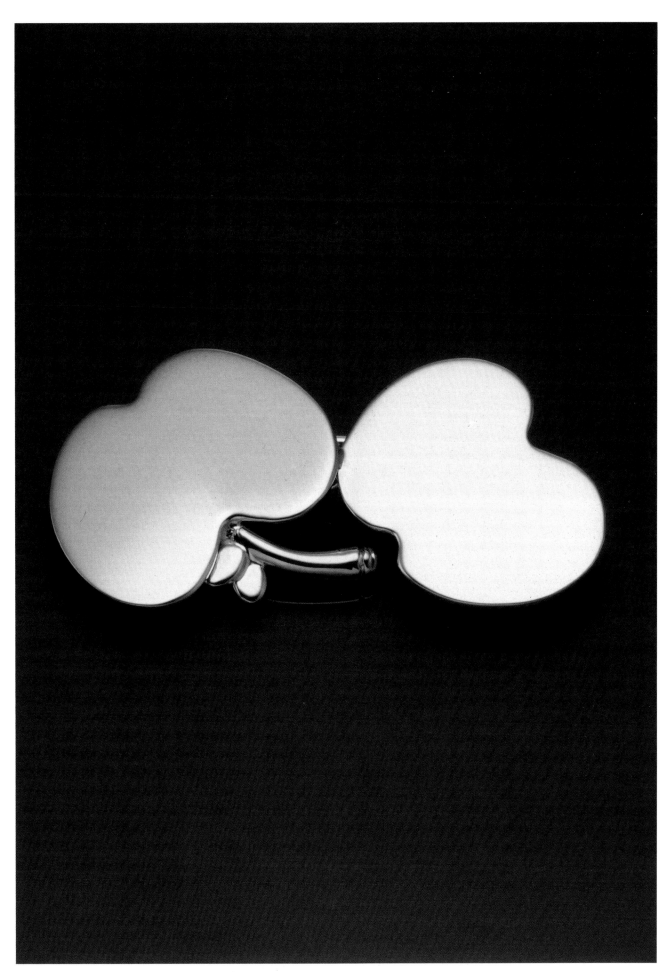

Gold brooch by Paolo Spalla (Private collection).

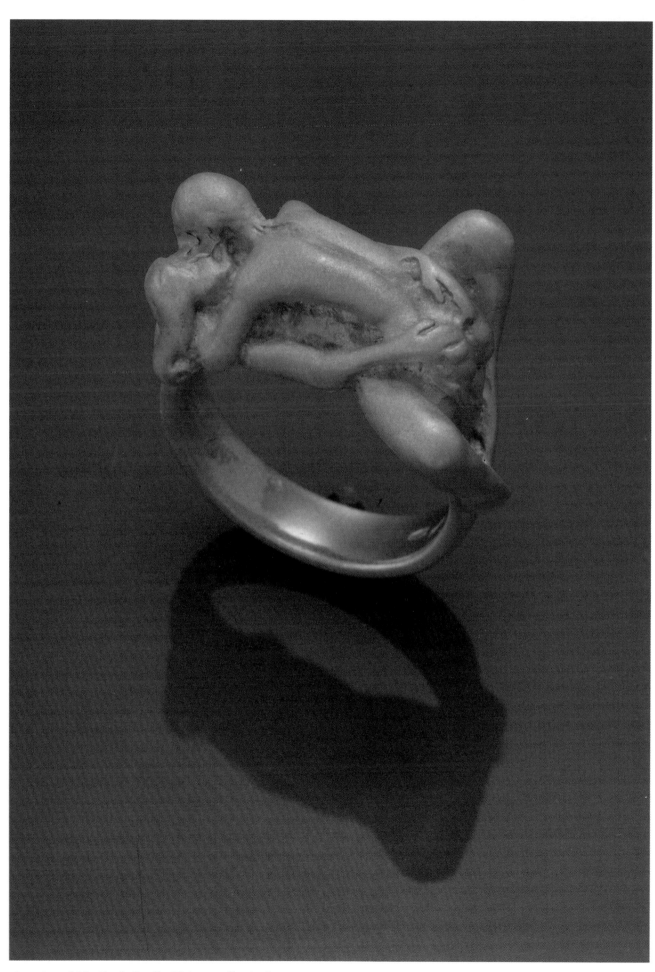

18 *Ring in gold by Paolo Spalla (Private collection).*

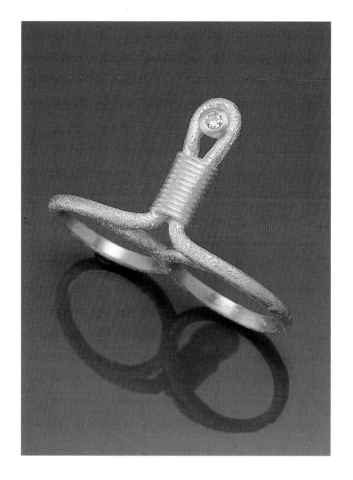

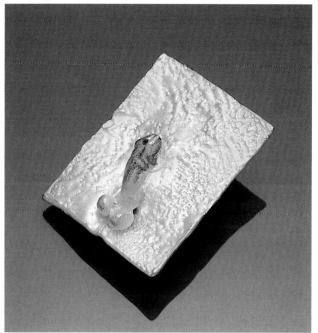

Pendant in white gold by Paolo Spalla (Private collection).
Ring in gold and diamond by Paolo Spalla (Private collection).

Perfumes for example have a strong effect on the psyche.

They lead you to the exhilaration of any kind of fantasy and imagination. And when you finally do have sexual relations with the opposite sex, the person you possess is never really important because you always carry ideal models inside. With time you build yourself up until you feel the needs of the other fully met. Women need to be freed of all the traumas of religion, of family education, of ignorance. I often wonder why with such a natural case comes that mental block, why the most natural thing in the world leads to neurosis.

There is really no culture of sex; it is the privilege of the few. For a woman to be completely liberated, she should not be born a virgin.

I believe that sex is so personal that there are no other suggestions I can make. My sexual experience is undoubtedly different from that of others. Everyone controls their own evolution.

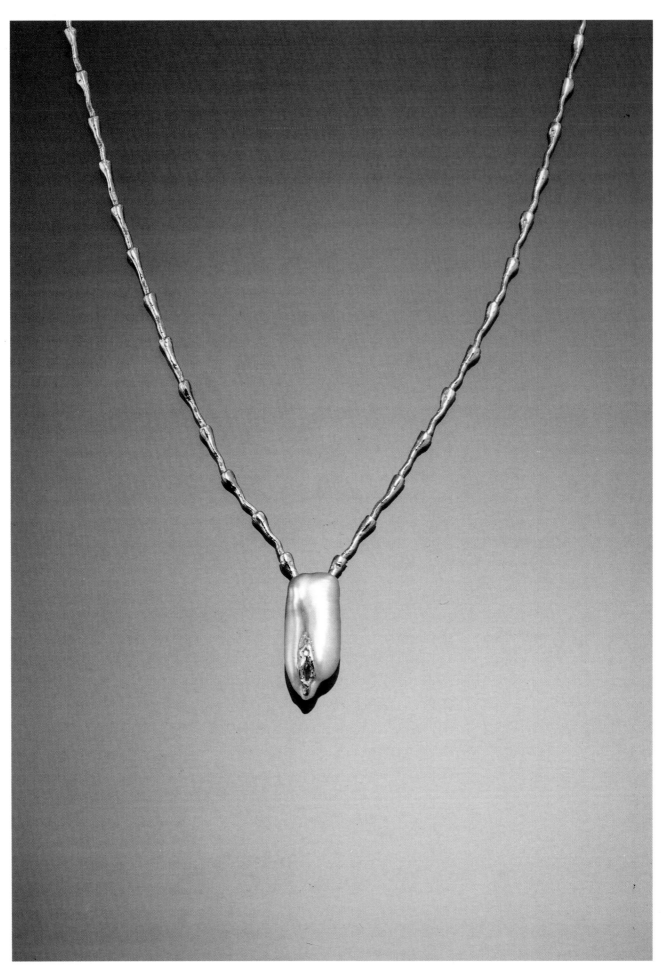

20 *Gold pendant with diamond, marquise-cut ruby, baroque pearl by Paolo Spalla (Private collection).*

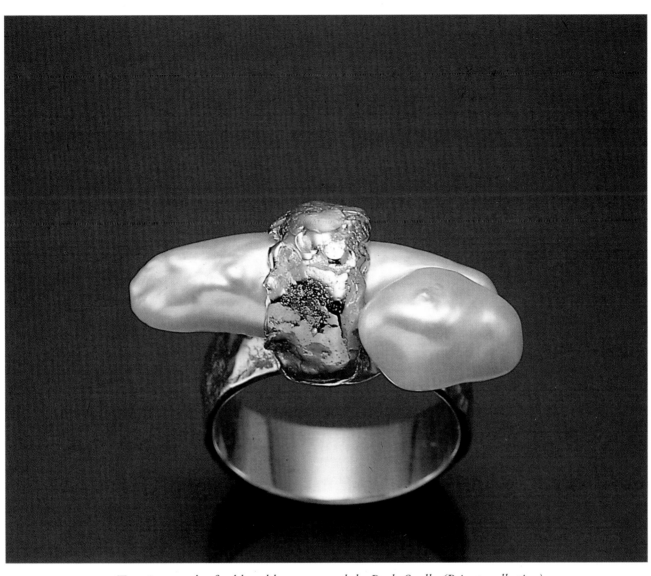

Two rings made of gold and baroque pearls by Paolo Spalla (Private collection).

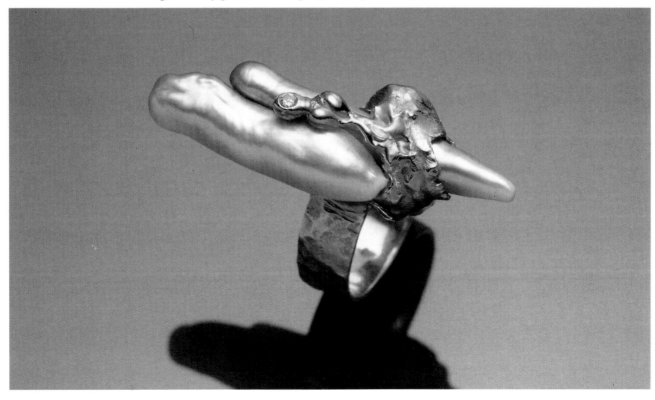

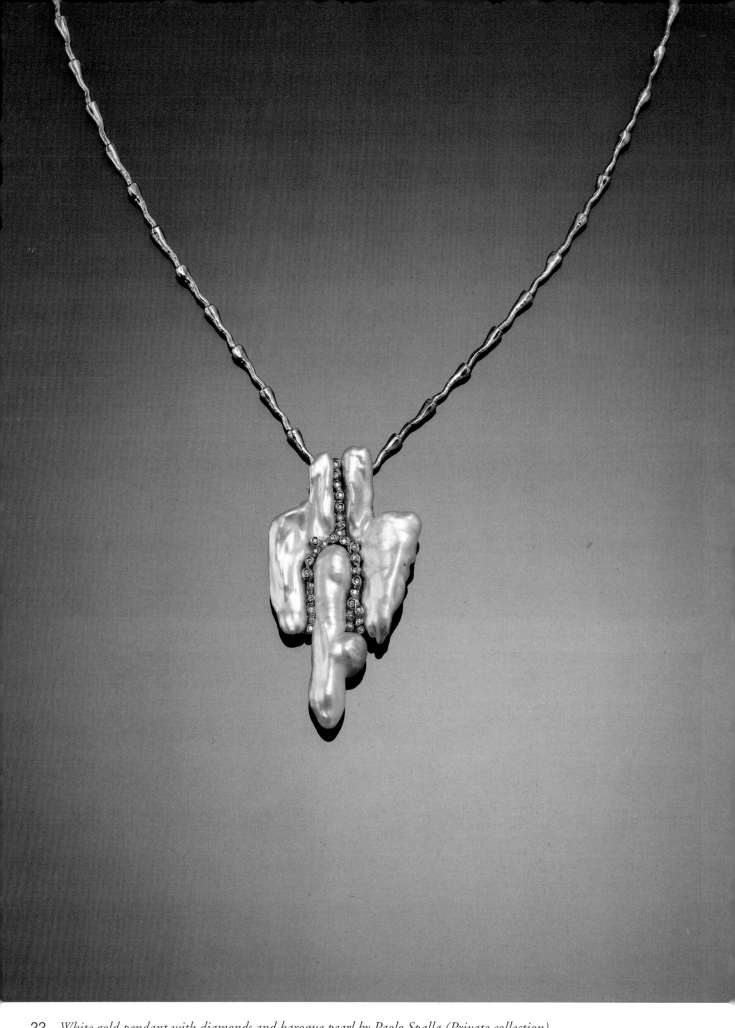

22 *White gold pendant with diamonds and baroque pearl by Paolo Spalla (Private collection).*

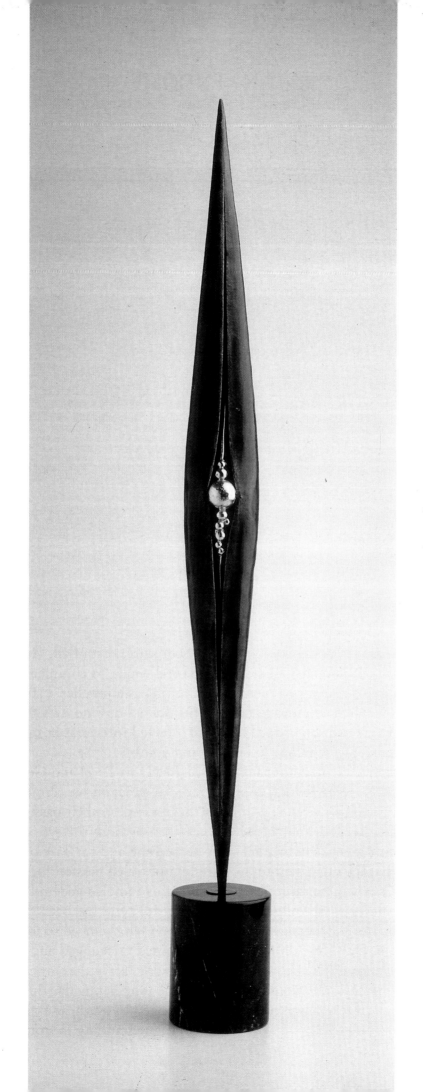

Sculpture of gilded,
bronzed brass by
Paolo Spalla
(Private collection).

JEAN VENDOME

An authentic giant of modern jewellery-making, Jean Vendome has created, many new forms and aroused renewed interest in gemstones. He has inspired countless newcomers in the field and created the "Sword of the Immortal" to admit Roger Caillois, Julien Green, Maurice Shumann, Henri Anouroux, Cuillame Guindey and Robert Marjolin in the Académie Française.

"Life is made of meetings… some of which… with men or with things… strike us so, that our way of thinking, our very imagination, is transformed. In most cases, these meetings and the subsequent, underground influences they have on our inner being, take place without our knowledge. Only later do we understand the importance. That is how it was for me. Many of my creations would never have seen the light if it had not been for…

"Sculpture, first of all. Going back to the period when, to complete and perfect my training as a jeweller, I studied for a time at the School of Fine Arts. It was a shock and it affected forever after my feeling for form and volume.

"Later Dina Level and George Gobel had a crucial effect on me. Professors of gemmology, they passed on their passion for stones, awakening both the eye of the specialist I was to become and the gaze of a poet. Since then, my unbridled passion for gemstones has remained unchanged and my love for beautiful gems has been sculpted on my heart.

"I soon felt the need to follow a rule that has remained unchanged and has guided me in all my work: 'serve the stones without betraying them'. One happy day during an exhibition, I happened to overhear a distinguished colleague standing in front of my work

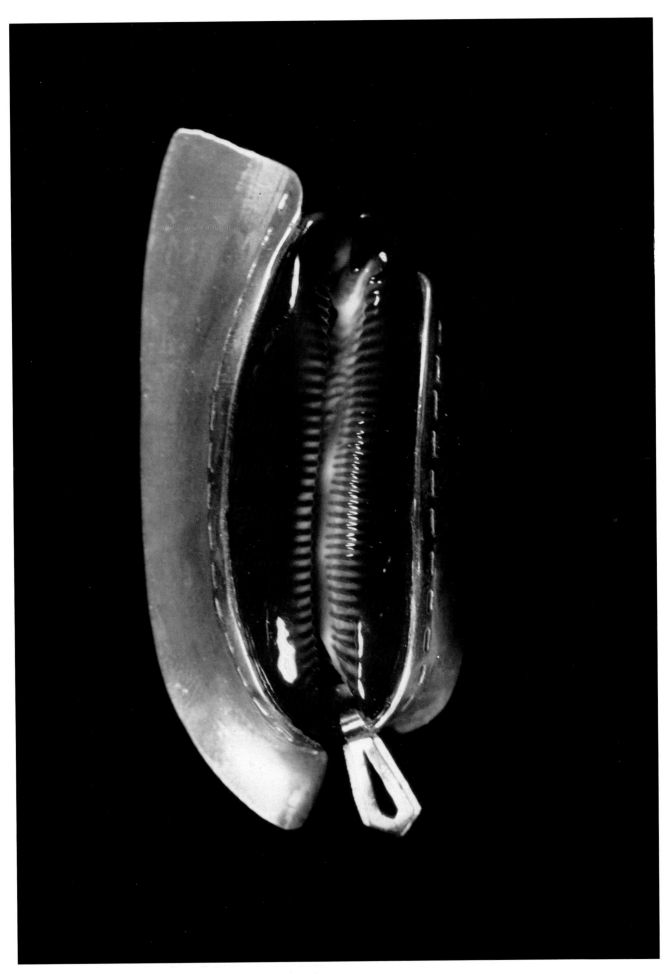

"Zipper", brooch of gold, silver and shell by Jean Vendome.

whisper to a friend, 'What respect he has for the stones! The jeweller in him knew how to step aside!' That was the confirmation that my fundamental concentration was understood and appreciated and therefore valid. I had taken the right road and now I was aware of it.

"My meeting with Roger Callois was undoubtedly one of the great events of my life. Nor was it a fortuitous event; this time it was organised by Dina Level and Henri-Jean Schubnel curator of the mineralogy gallery of the Paris Museurn. Callois, author of *L'écriture en pierres* had been elected to the Académie Française and wanted me to design his sword, a basic accessory to the costume worn at the ceremony. I was touched by the man's simplicity, by the vastness of his knowledge he wanted to share with me and by the friendship he knew how to give. His memory and the recollection of his friendship are forever imbedded in my soul.

"His gem collection, containing some extremely rare examples, is a response to his attachment to the symbolic, to the unusual. The sculpture-like beauty of the collection is unique. It is currently stored at the Museum of Natural History of Paris where it will be placed in the new rooms being constructed. "It was Jean-Paul Poirot's idea to speak to me of the Bariands. Poirot is director of the control labs for precious stones of the Paris Chamber of Commerce. It was in fact a felicitous idea, and the occasion for a new, extraordinary encounter. Pierre Bariand, curator of the mineral collection of the Sorbonne, and his wife Nelly, enriched the collection, universally recognised as one of the world's finest, with exquisite taste. To miss seeing this dazzling collection of exceptional crystals means denying oneself a fabulous spectacle of light, form, and colour.

"Studying the heart of a stone pulls me out of our paved, labelled and standardised world. Gemstones for me are an escape, a dream, the chance to wander, seek and reach the essential…

"No civilisation has developed without gemstones, without silica, without the minerals from which metals are extracted. The history of humanity is closely tied to minerals… Cities, ruined palaces and columns, the urns, cups and jewels preserved in our museums are testimony to the ancient art of living with stone, and with stones.

"It is superfluous to say that stones have accompanied my entire professional life. Like anyone else, even a famous jeweller needs signs of understanding and trust. The first people, the customers, who followed and encouraged my work swiftly became and still are my friends. I am very, very grateful to them.

"Stones, meetings, joys and sorrows were shared from the moment we met and for thirty years, all too short, with the woman who was constantly at my side, patient, solicitous and efficacious, my wife Nelly. Her voice, her gaze, her name are part of me, in the depths of my being, unchangeable."

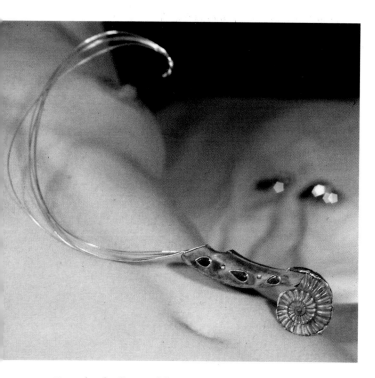

Brooch of yellow gold, ammonite, wood and emeralds by Jean Vendome.

Now, let's hear what the Encyclopédie Larousse has to say about Jean Vendome: "Vedome (Jean): French jeweller (Lyon b. 1930). After finishing his studies at the Ecole des Beaux-Arts, Paris, he worked as an

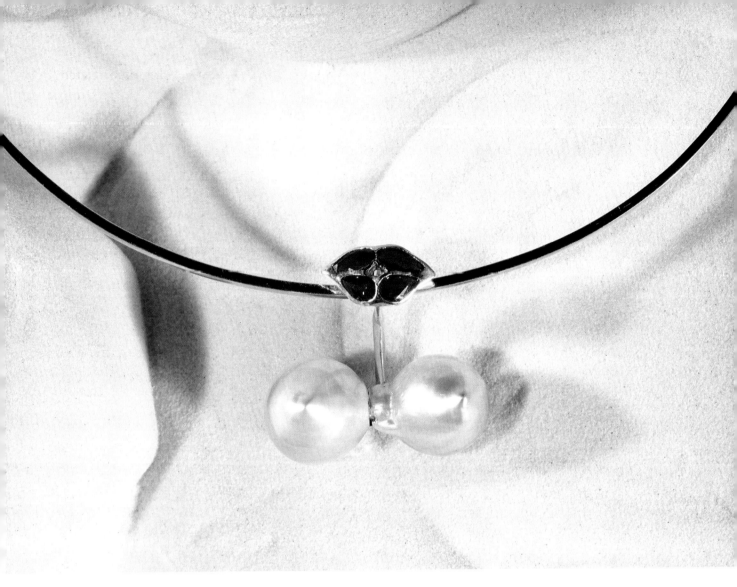

Necklace of gold, pearls and rubies by Jean Vendome.

apprentice and took a series of courses in gemmology that strengthened his love for the natural beauty of gemstones. He opened a shop when still very young (1951) and in 1967 exhibited for the first time at the Salon des Artiste Décorateurs, the first of many exhibitions. His jewels were shown alongside those of Braque in Paris (1968); he represented France at the exhibition of designer jewellery in Tokyo and Marina di Carrara; he took part in the exhibition Presige de l'or on the theme 'New Lines' in Paris (1971). He later exhibited in Bruxelles (1973)…

"Jean Vendome's production is marked by his very personal, very rich imagination and an in-depth understanding of his craft: 'S' ring (1969), 'Boule' ring (1972) which can be slipped on the figure in three different ways, etc. With his boundless love for the beauty of gemstones, Jean Vendome works the metal with the aim of echoing them, giving shape to what his inner eye sees: 'Manhattan' necklace (1970); 'Earth-Moon' brooch (1973); 'Solaire' necklace (1973); pendent-plaque inspired by totems (1974).

"Solid or airy, simple or baroque, his jewellery bears the Stamp of a jewellery whose approach and creativity is totally contemporary."

STEFAN PAULI

A leading figure in the field of Swiss design, Stefan Pauli has created a series of wearable mini-sculptures that perfectly illustrate Edward Lucie-Smith's words; "At the dawn of art, the sacred and the erotic were closely related."

"Trust" and "Passion of Love" by Stefen Pauli, in gold and diamonds.

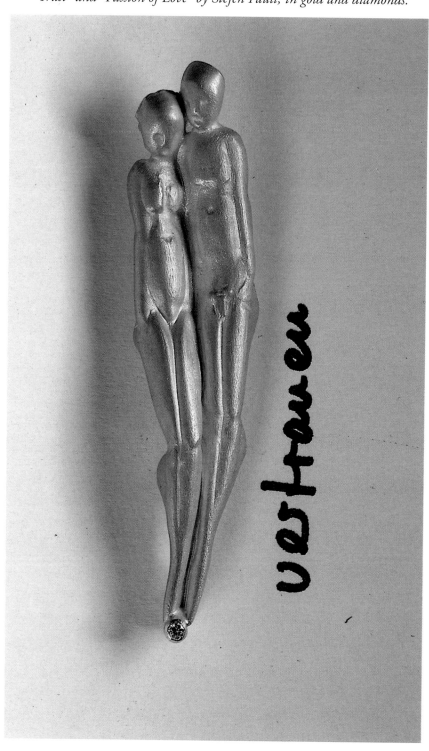

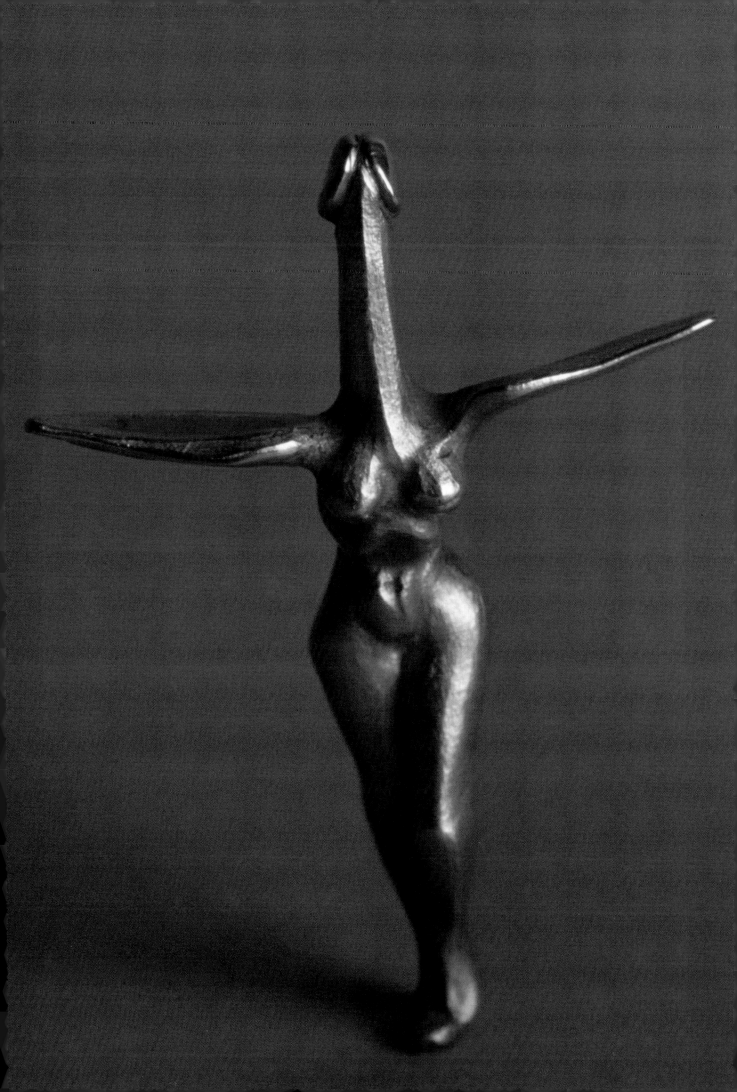

A jewel is an ornament for the body, but it can also have its own identity, far and beyond the surfaces decorated by the artisan's hands.
The coloured stones are the artist's palette, the metal's form and lines, her brush.
However, jewels are not only decorative objects. Quite the contrary, they often resemble other art forrns, miniature sculpture, for example. So the jewel interacts directly with the human body, revealing the personality of the wearer and simultaneously expressing thought and emotion.

"The Angel of Love", necklace in gold, diamonds, citrine quartz and pearl by Alice Hsiao-Yuan Lin.

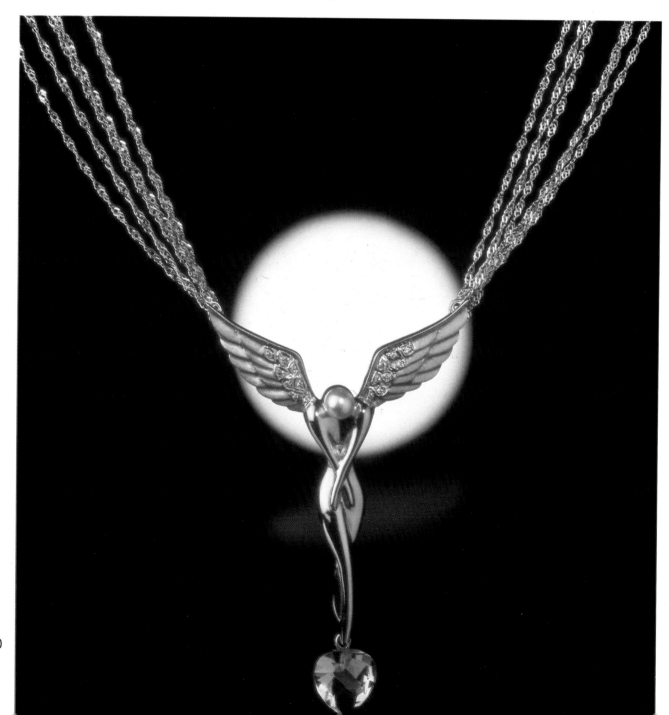

30

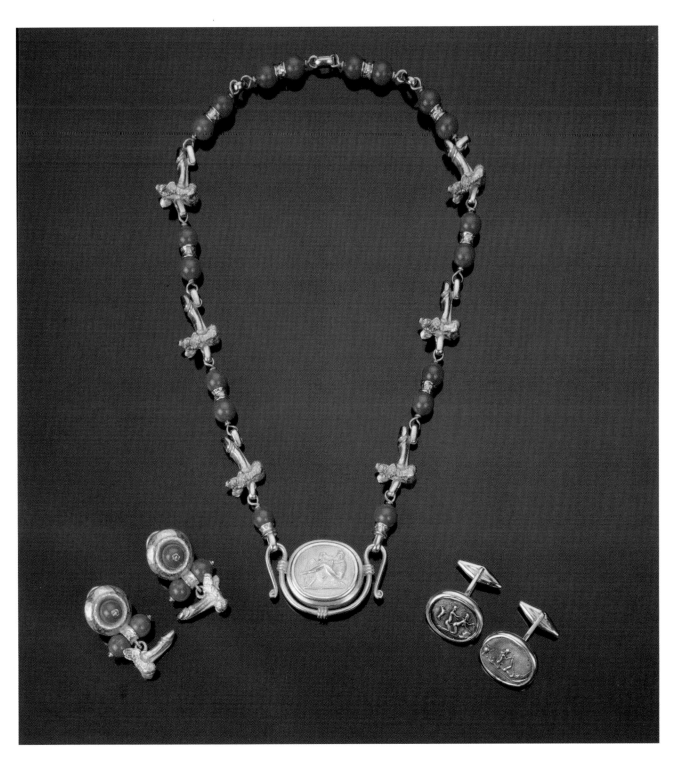

Yellow gold and coral parure (Cellina Barth collection). Cuff-links made of gold and silver coins.

\mathcal{T}hanks to her collaboration with master Roman craftsmen, Cellina Barth, with a passion for all the "precious" things in art and life – eroticism in particular – has commissioned extraordinary erotic pieces for her private collection.

31

DEBRA DEMBOWSKI

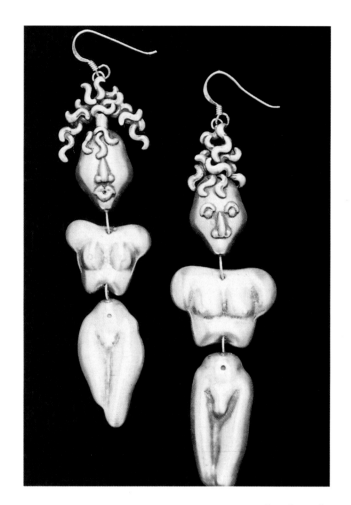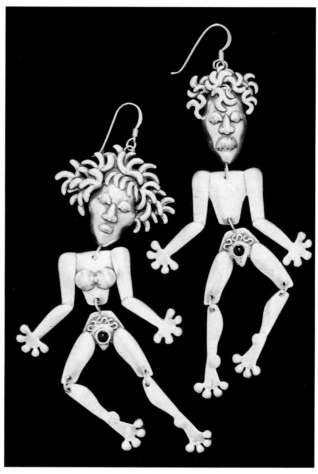

"Male and Female", earrings.

*T*he dominating element in Debra Dembowski's pieces are the nude, the nude couple in particular. The original design of these earrings, depicting a blatantly naked man and woman, points to a somewhat naïf, primitive eroticism. It has a restive charm, giving out messages the eye captures, both ironic, and libertine.

STEFANO MICHELANGELI-POLIMENI

*H*is hobby is creating in general, jewels in particular. Although he was a student of mine for some time, I consider him to be an authentic self-taught artist. Once his idea is in place, the technique that he applies to realise the piece simply comes from logic. Making a sculpture, a bas-relief or a jewel is an act of creation, the result and the dimensions depend on the quality of the raw material and the person who will use the object.

In jewellery, Stefano Michelangeli-Polimeni has launched a style of jewel, called "Le Volage" ("Flight of Fancy"), that is very symbolic, romantic and sensual.

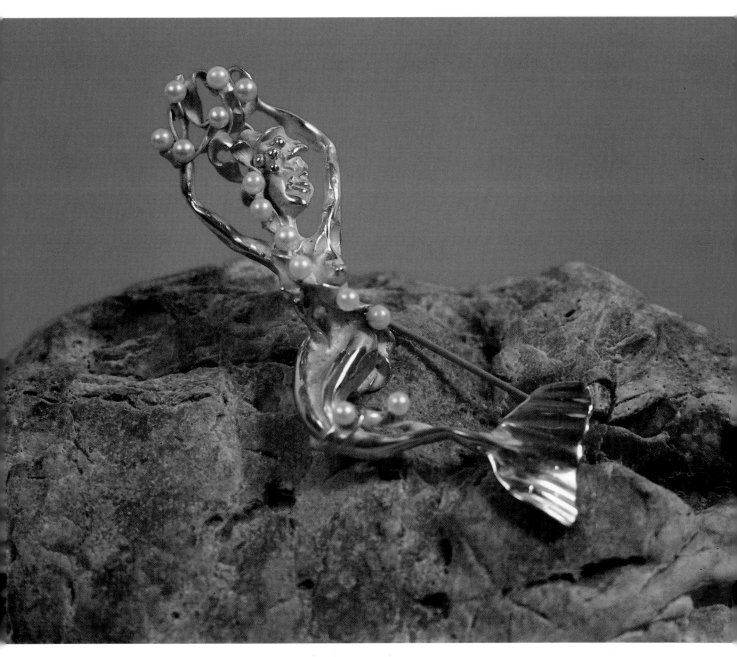

Mermaid in gold and pearls. One-of-a-kind piece.

33

GÜNTER KRAUSS

A mythical name, known all over the world, seen in some of its most important museums. His creations are precious additions to prestigious private collections. It is not only a privilege to possess one of his works, it means ensuring yourself a tiny fragment of thirty years of activity rewarded with a large number of prizes and acknowledgements of every kind.

For this occasion, Günter Krauss has united his talent to the imaginative ideas of Tomi Ungerer, another recognised international celebrity, Commandeur de l'Ordre des Arts et des Lettres and Chevalier de la Légion d'Honneur, to create together a fabulous collection of erotic jewellery. Descriptions are useless. These masterpieces speak for themselves.

symetid

POKER FACE
oder Pair of aces.—
oder Deuces

34

So ein Schwein!

(Hexenritt)

36

DIE LIEBE IST BLIND

(ohne Wehrleistung?)

ein schraube.

beine
anschaub-

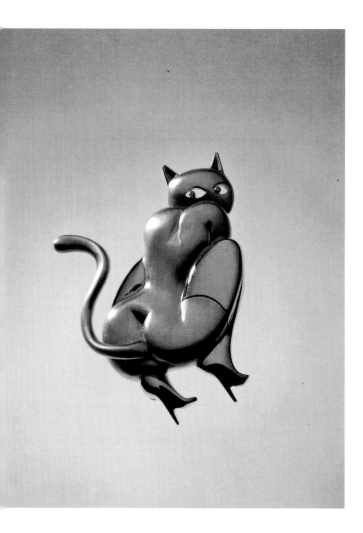
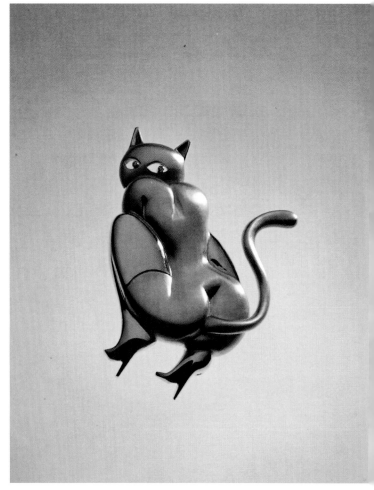

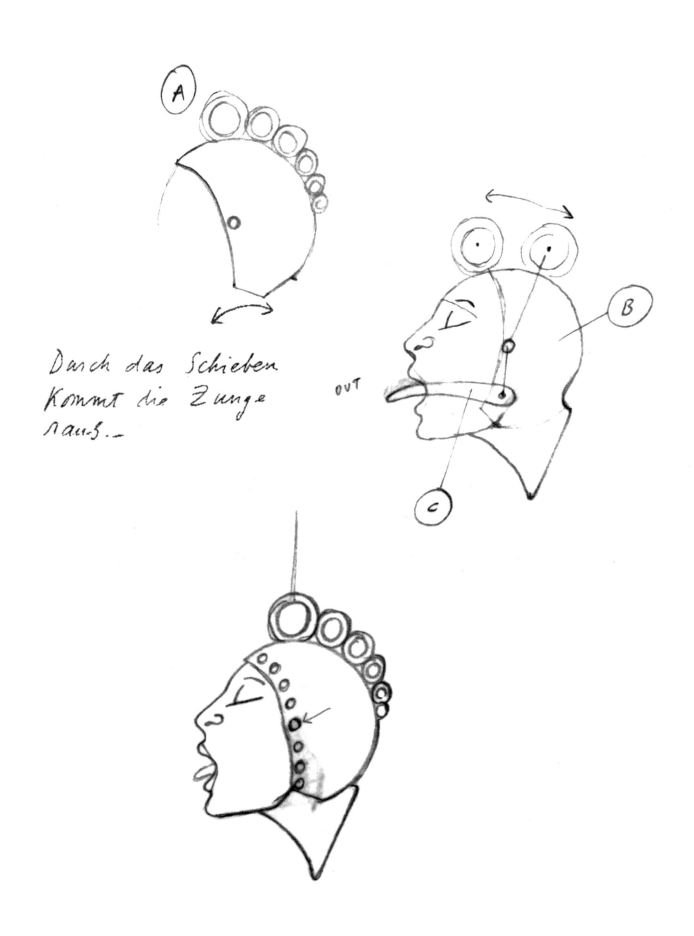

Durch das Schieben
kommt die Zunge
raus.-

40

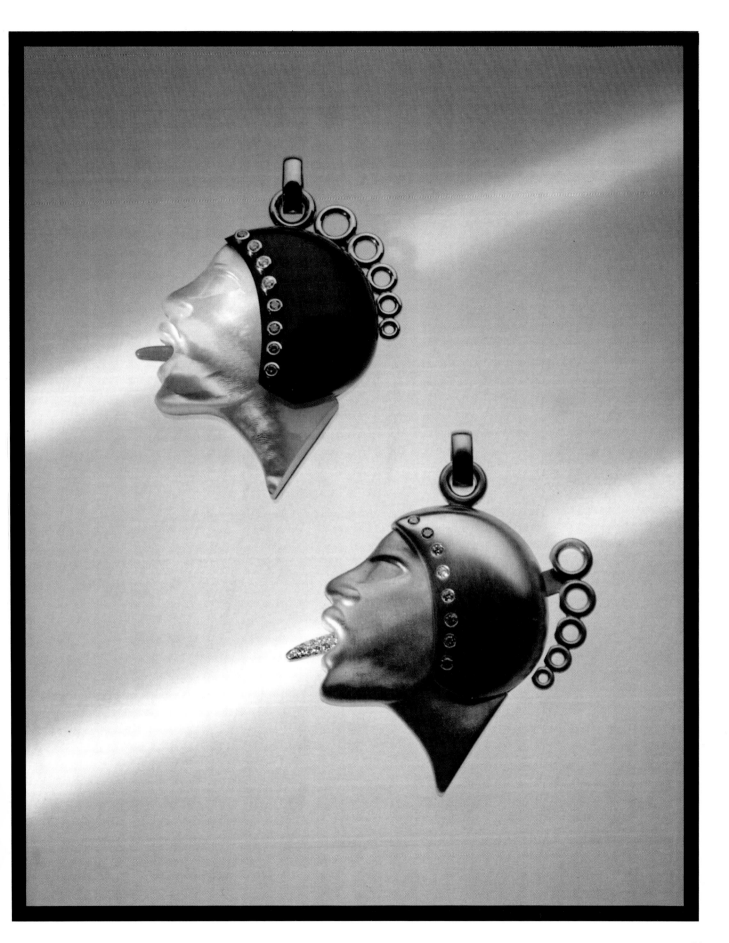

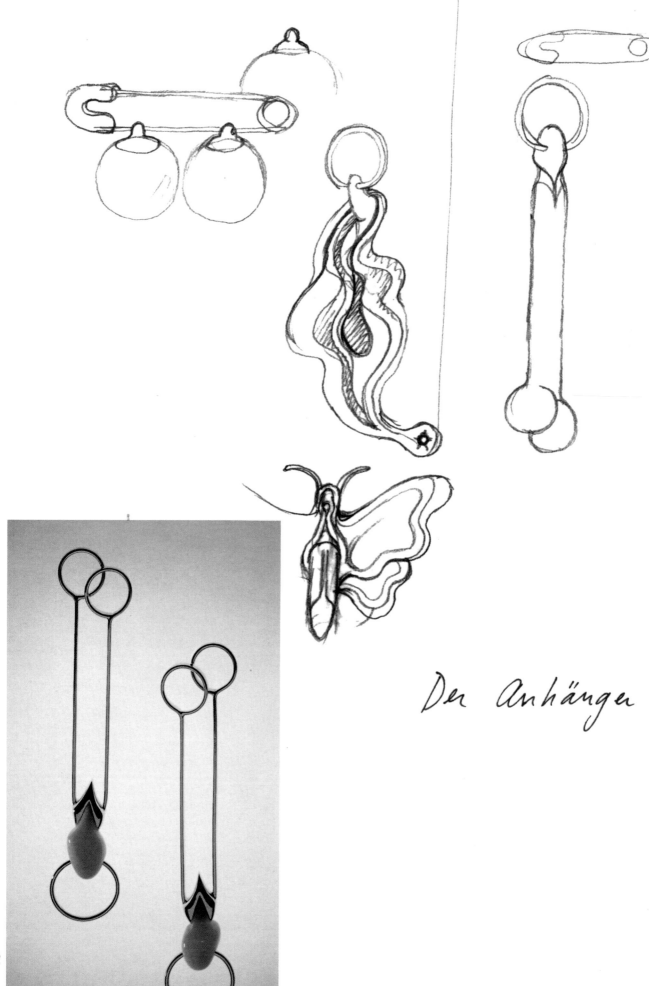

Der Anhänger

42

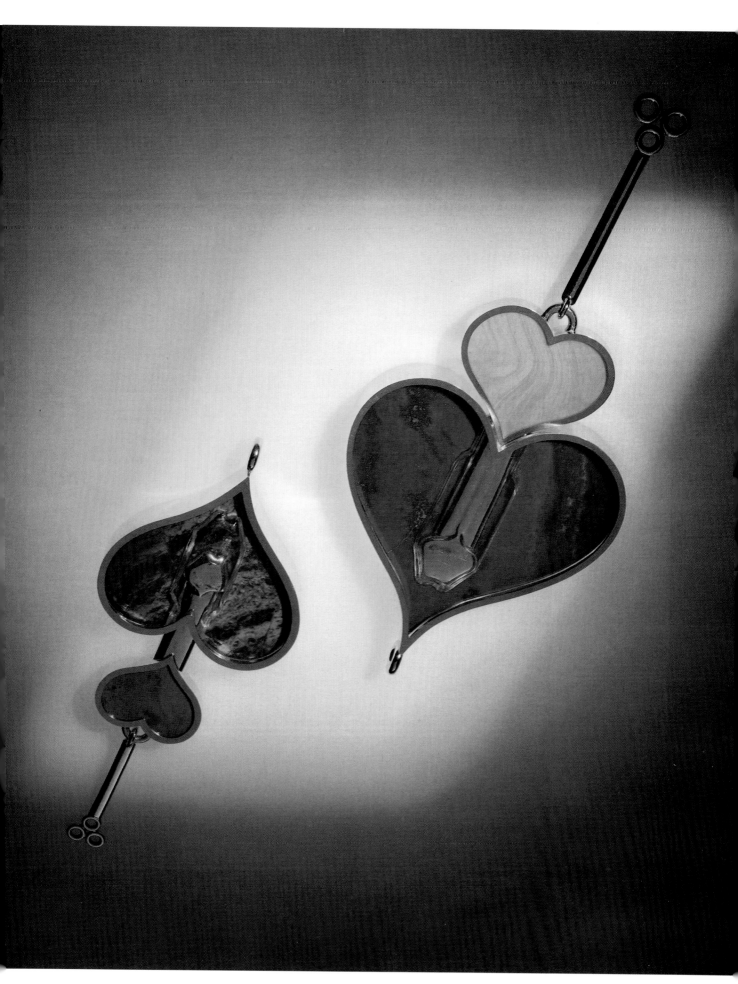

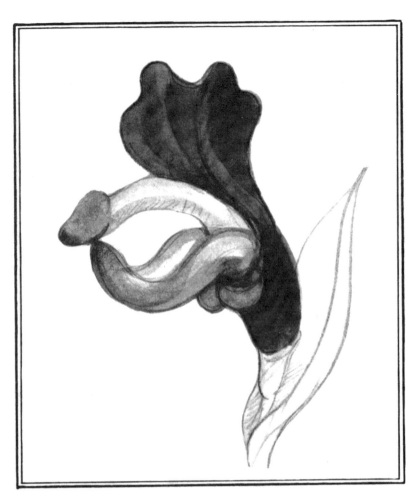

Voluptiphallus autofellator

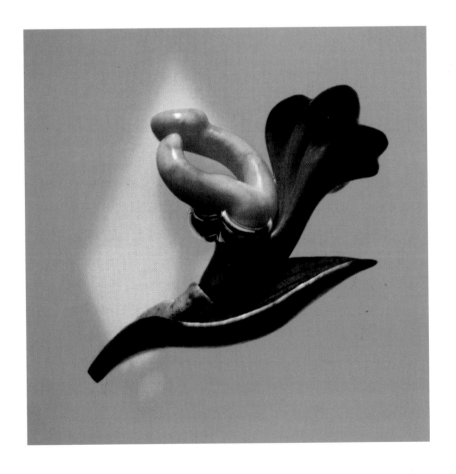

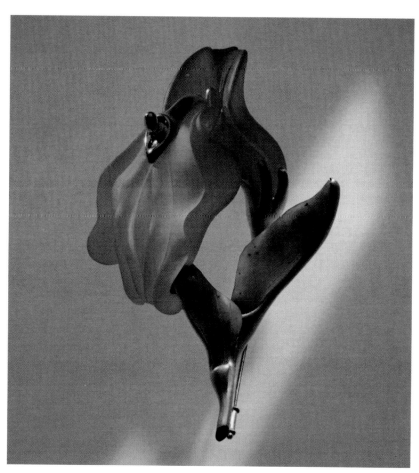

Orchis clitoriderecta

45

WOLFGANG JOOP!

asn't it Eve, with her rounded figure like the shape of an apple, who took away Adam's peace in his Paradise?

And wasn't it again Eve who, together with the phallus-shaped serpent, convinced the unlucky inhabitant of Eden to bite what was forbidden, be it fruit or flesh?

And who, if not her, demanded that her companion provide her with clothes, furs and anything else she needed to cover her nakedness?

Who aroused Adam's desire with blandishments, turning him into a hunter for her woman's body?

And now we can possess her!

Forged in gold and decorated with precious stones, her sumptuous body becomes a fetish.

"If she intoxicates you, you cannot resist her!"

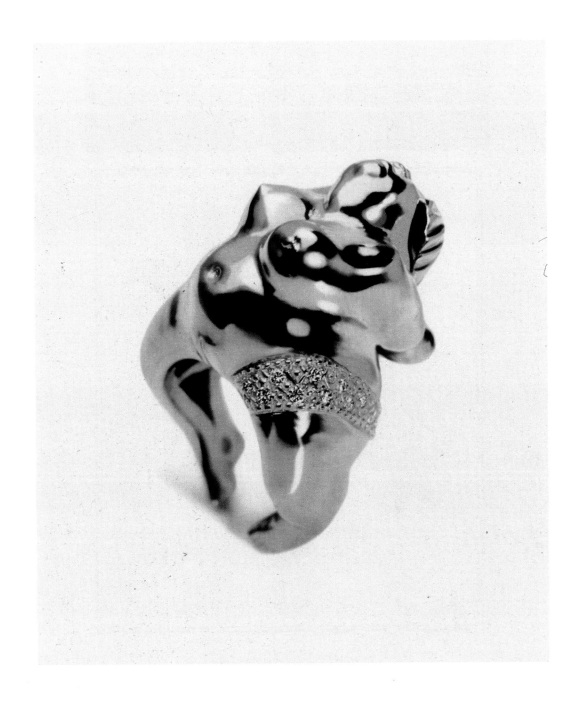

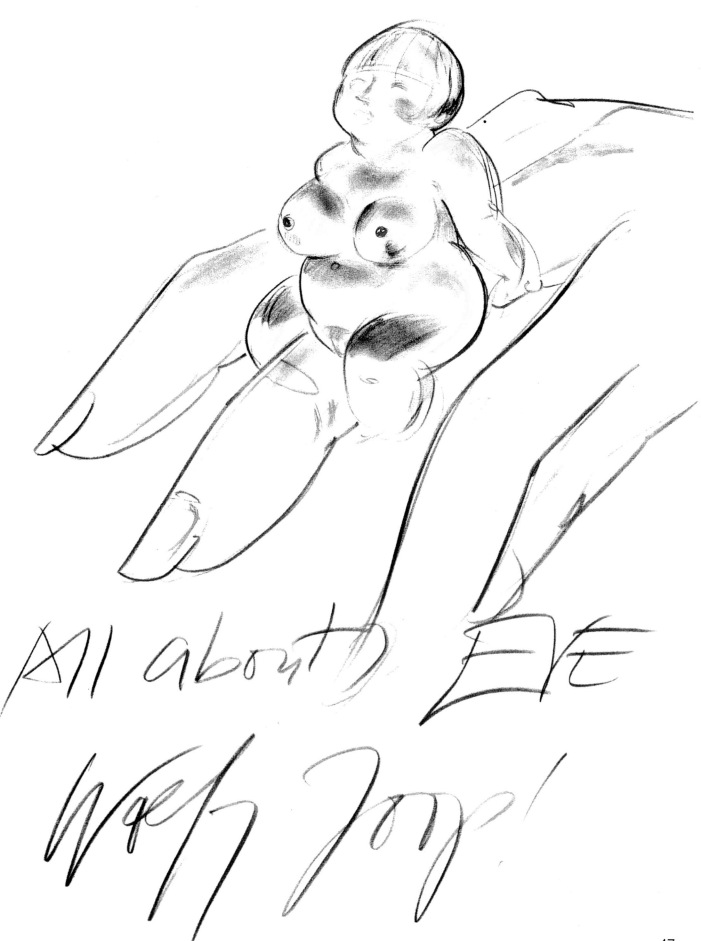

All about EVE

With Joop!

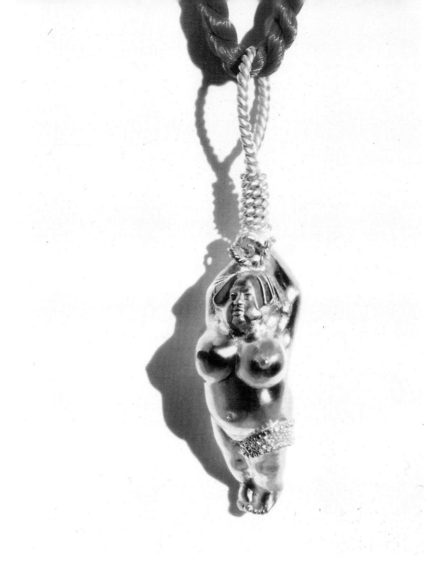

Gold and diamond parure from the collection "All About Eve" by Joop!.

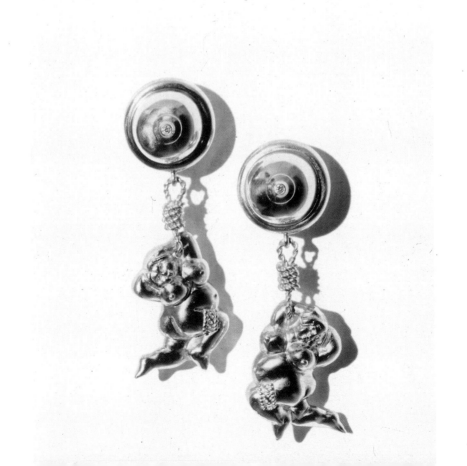

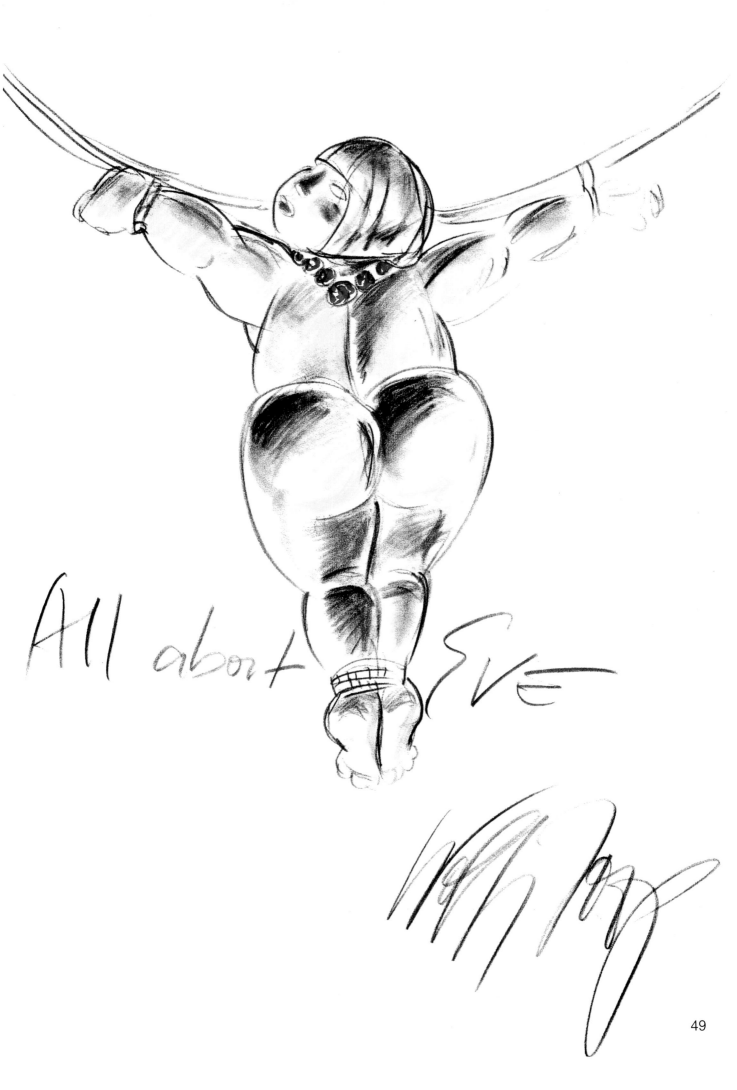

All about EVE

49

Michael Zobel, creator of jewellery in Costance, Germany.

THE ABSTRACT

In collaboration with Michael Zobel

*S*aying that Michael Zobel was born under a lucky star would be limiting his real worth because this artist is one of the century's greatest jewel creators. His birth in Algers, Morocco in 1942 was the starting point of a long journey around the world, each country leaving its cultural mark on the artist's imagination.

Michael Zobel's early years were spent in Barcelona, Spain. In 1958, he moved to Pforzheim to study art and drawing. It was in Paris in 1965 where he started his profession as a jewellery designer. During his stay in France he met the young Annick, who was later to become his wife. In 1968, overcome by a desire to settle somewhere on the planet, he ended up in the city of Costance, Germany. The happy culmination of memories of his Mediterranean past was the opening of a studio on the shores of the lake which Zobel loves calling his 'German Riviera'.

Upon entering his studio, our attention is drawn to a calendar where Zobel has circles around the dates of appointments in the far-flung corners of the globe. He takes part in prestigious international trade fairs, like the Basel Switzerland fair and exhibits in Athens, Las Vegas, Minorca and the rest of the world.

Michael Zobel is an irresistible human being, a combination of wit and affability, with a zest for life and a talent for success in all he does, from dance to sports to gardening. He is passionate about what he loves and he loves with passion, as his painting and sculpture collections show.

All this energy is reflected in his artistic creativity. If the size of his jewels – bona fide objects all – are startling, they also help us better understand his personality, his engaging pride, his wide, generous gestures, his exuberant joy of living.

Zobel's jewels are important designs with broad lines, crafted into distinct forms with a great wealth of stylistic variation. Other distinctive features of his art are the arabesques in varying patterns and the different colour combinations.

Zobel loves to mix 21 or 18 carat red gold, palladium, and platinum with integrated silver, often niellated with the 24 carat refined gold he favours. His opaque, silk-like surfaces recall the granulation used by the ancient Etruscans; only the contrasted points have a burnished surface. The union of precious metals and materials such as leather, glass and wood is one, of his primary methods of experimenting with different colour combinations.

All of Michael Zobel's work is permeated with an exotic perfume, the palpable recollection of his many trips around the world. Typical material from the various regions Zobel has visited are an integral component, along with the spiritual experience that Zobel instils in his creations. The scientific names of stones no longer hold any secret for him. When he designs a piece, his imagination roams from the physical appearance of the person who will wear the jewellery to her specific personality. His 27 years of artistic activity enable him to create

51

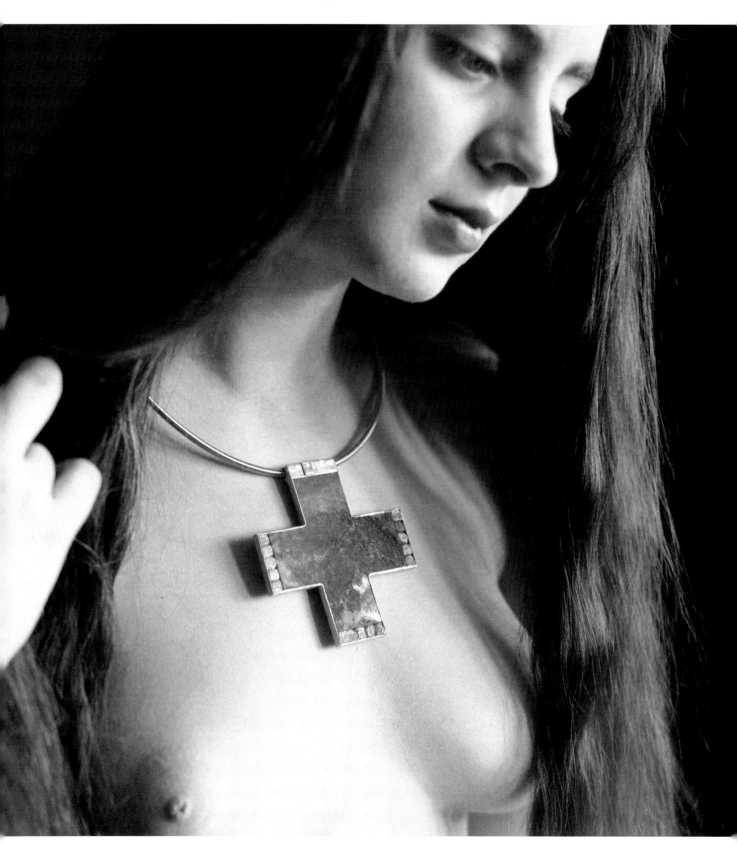

Gold and platinum cross studded with rubies, rough diamonds and princess-cut diamonds by Michael Zobel.

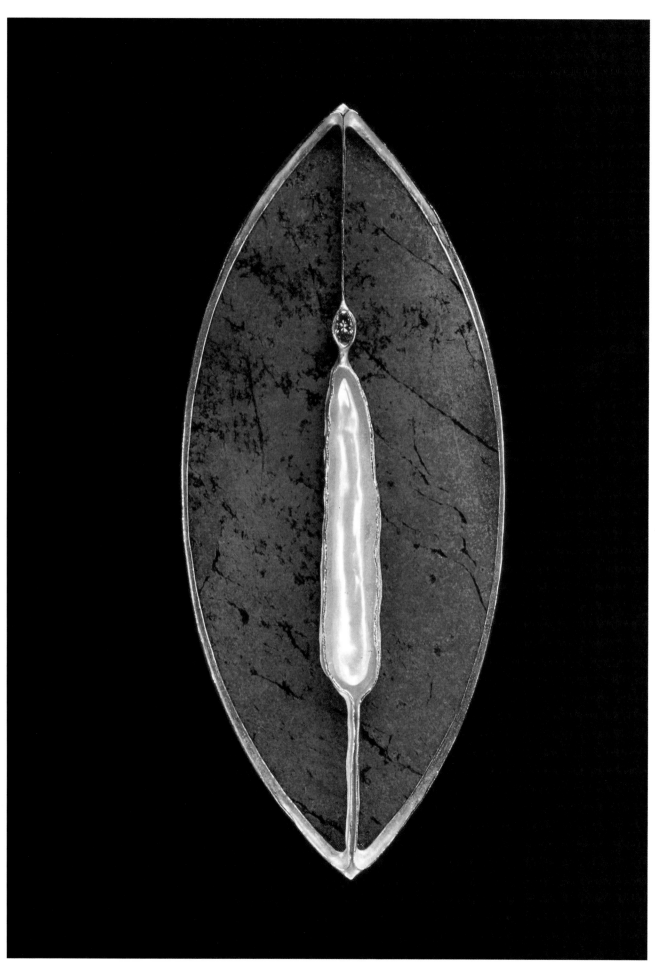

Pendant-brooch made of gold, dumorterite, diamond and biwa pearl, by Michael Zobel.

a resemblance between his pieces and the wearers. One of Zobel's most highly appreciated qualities is his rare sensitivity in grasping his customers' innermost essence by accentuating, underlining or synthesising their personalities.

Jewellery designed by Zobel always emanates an irresistible erotic aura. The Egyptian pharaohs and Aztec kings would certainly have been enchanted by his spectacular necklaces, wide bracelets and rings, authentic sculptures turning the hand into a veritable jewel-box. This artist's greatest reward is to catch the beginning of a glimmer in his customer's eye, a sudden gleam which kindles the love story between person and object.

The road Zobel has travelled since that far off day in 1968 when he arrived in Costance is long. His memory has not erased the difficulties of his beginnings when all he had were a few stones, a little money and his old car with its two-horsepower engine. Standing in front of his shop – a veritable jewel that Zobel has opened in one of the loveliest areas of the old city – it is hard to imagine today.

The shop is decorated in a very special taste with windows that are photographed and conceived as sets to highlight the presentation of the jewels which Zobel is fond of describing as "objects of desire".

A desire for pleasure or the pleasure of desire. Zobel's great sensuality, permeated with exotic perfumes, settles a cloud of eroticism, a shadow of sexuality, veiled by modesty that is just as great.

Zobel's many shows all over the world, the numerous prizes he has won, the pieces exhibited in some of the most prestigious galleries of New York, Chicago, Paris and other world capitals are only a pale reflection of his genius, courage and unique technique that amalgamates matter to create harmony.

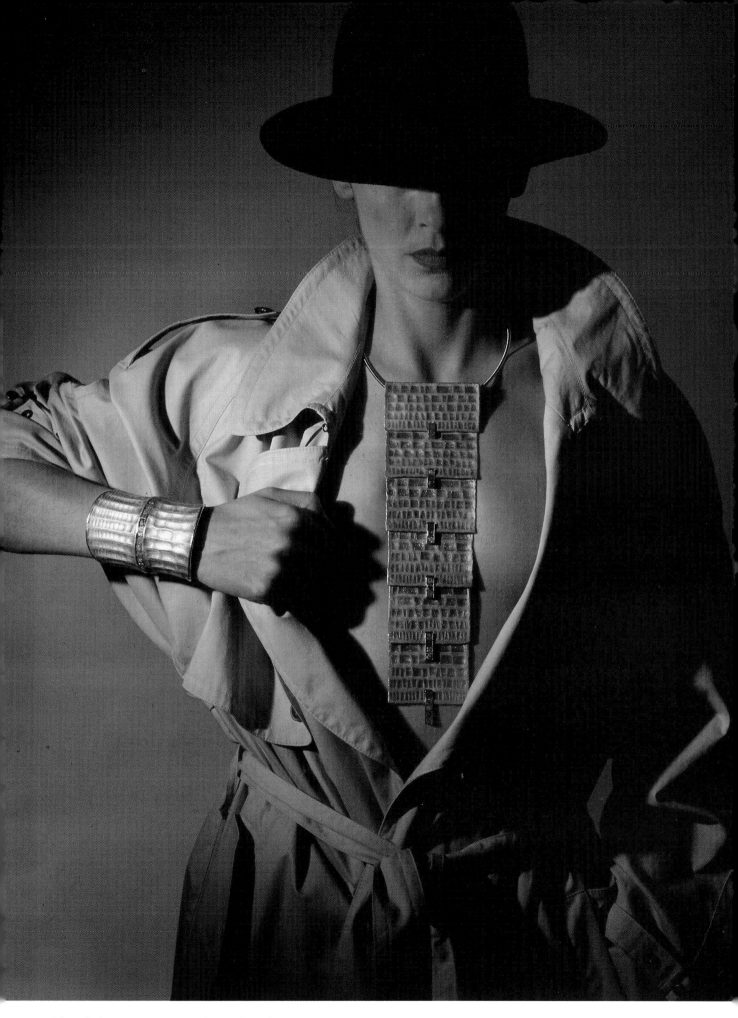

Gold and platinum parure with rough and cut diamonds by Michael Zobel.

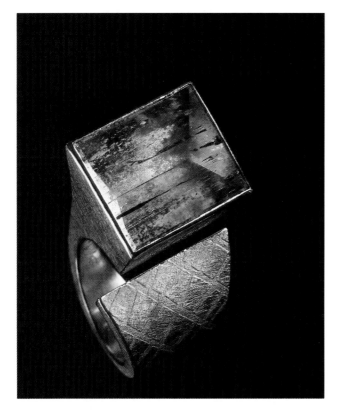

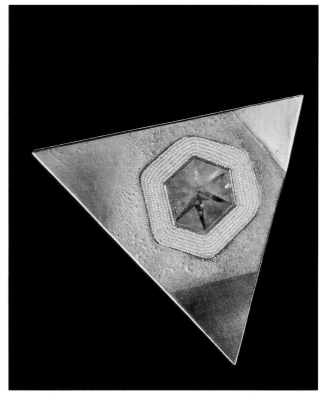

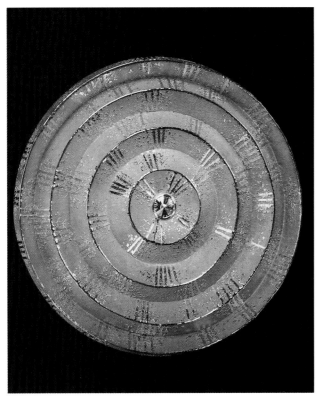

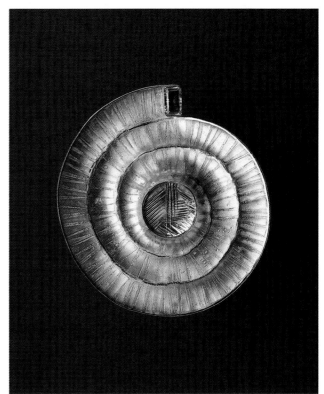

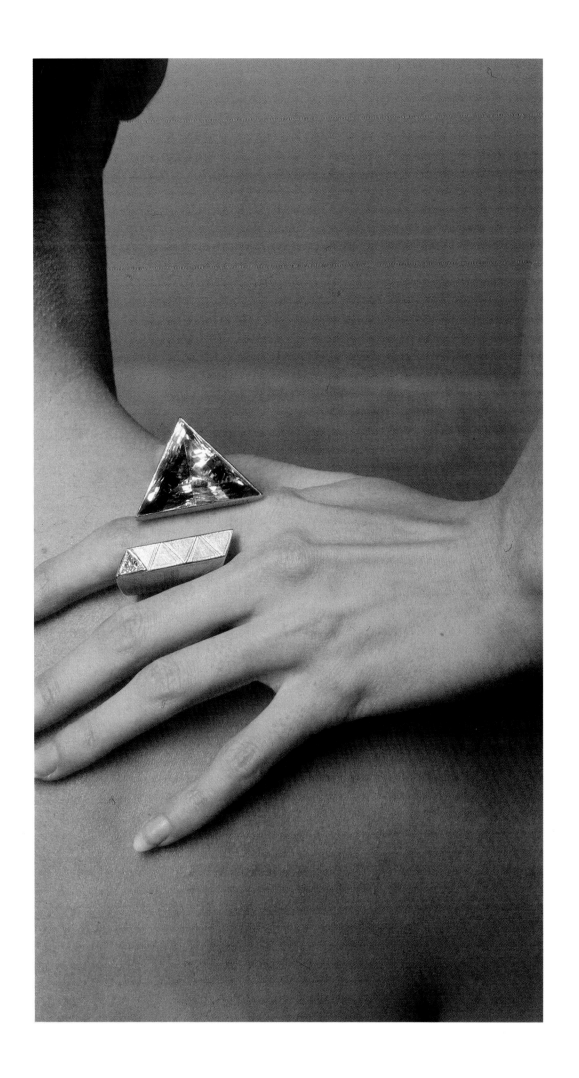

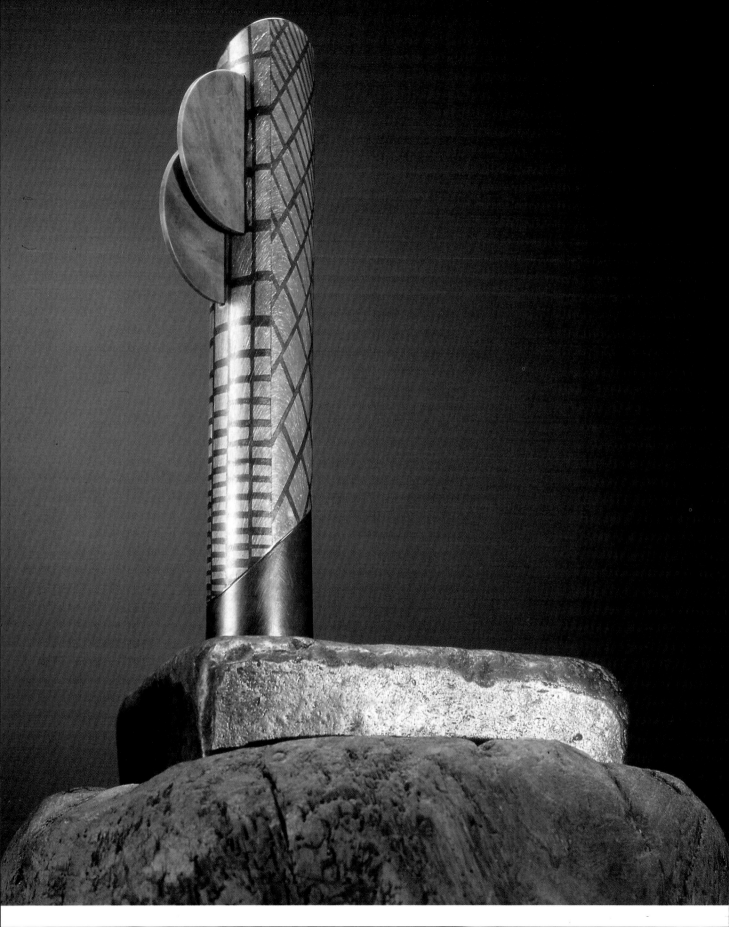

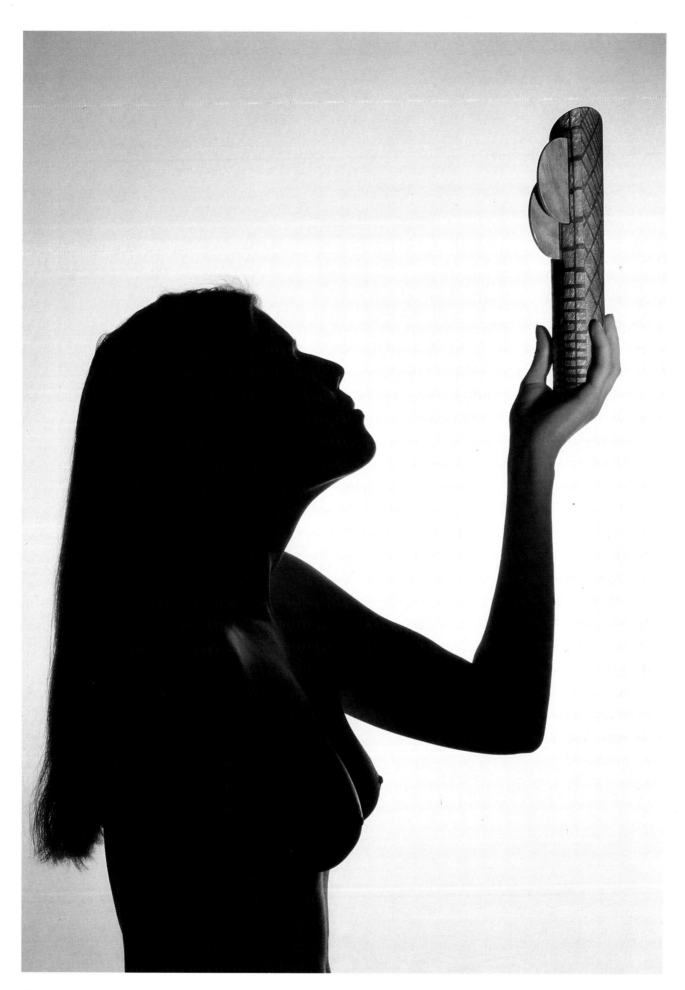

Sculpture and object that can be used as a pendant created by Michael Zobel of pure gold, silver and dumorterite. 59

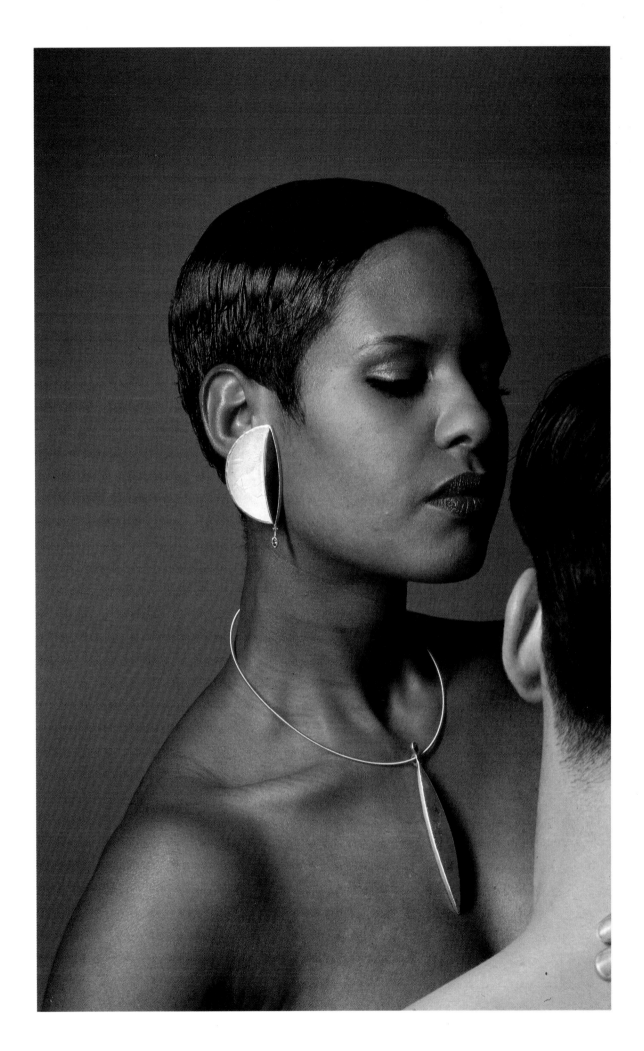

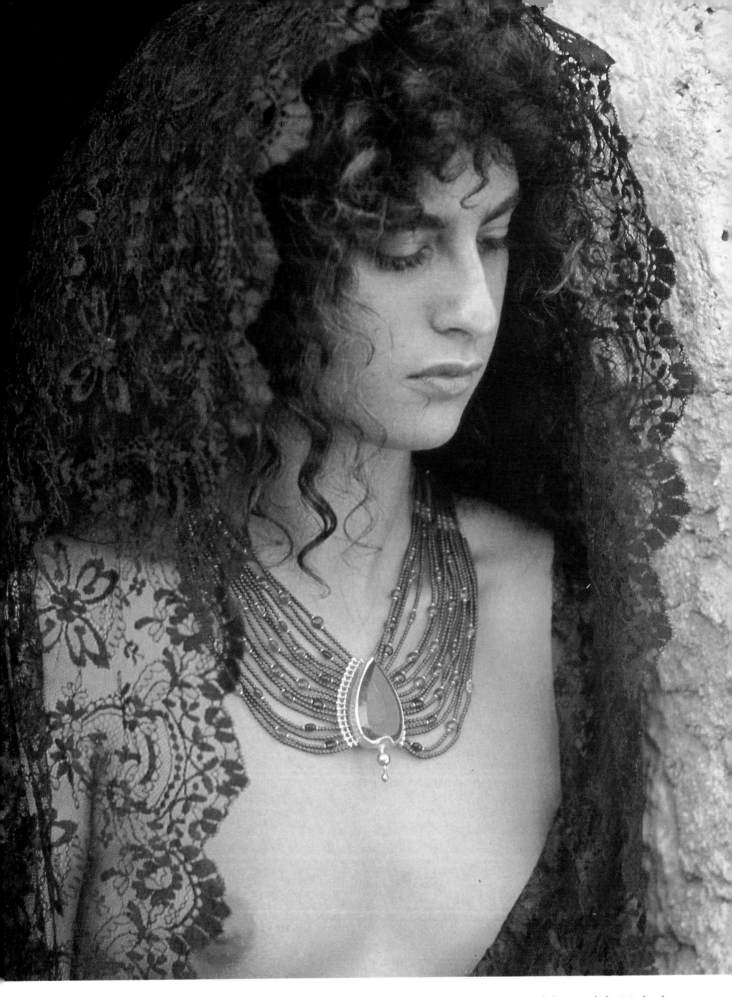

Gold necklace with hematites, fire opal from Mexico, black pearl from the East and coloured diamonds by Michael Zobel.

JEAN-PIERRE DE SAEDELEER

"*How* lovely to have a woman's body
at my disposal when I create!
As my jewels take shape I have the sensation of
playing with pearls of eternity, seeing them
with a casing of flesh.
We are all alchemists and so we remain,
everlastingly searching for eternal beauty.
The disquieting forms of my jewellery are
inspired by what determines the difference
between man and a woman: her rotundity,
her sex.
The rest takes place playing with fusion and in
the play on the passion".

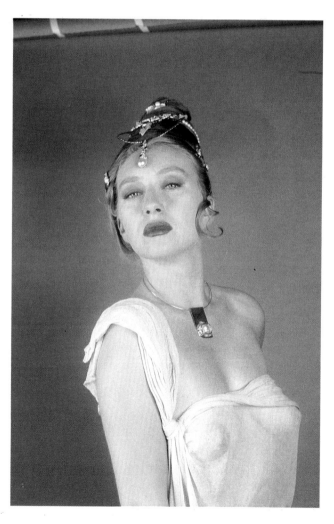

Femininity and sensuality emanate from Jean-Pierre De Saedeleer's jewels.

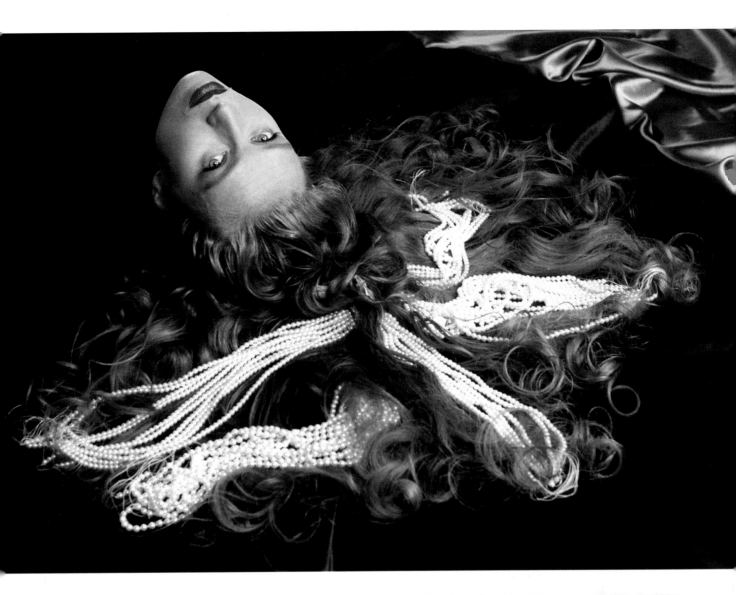

Pearls have often
inspired Jean-Pierre
De Saedeleer in the
creation of his
collections.

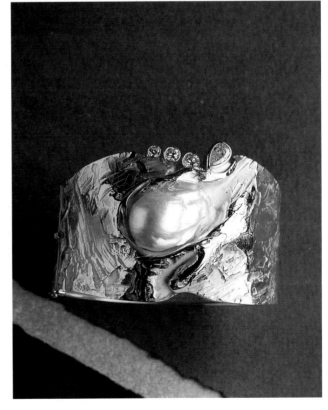

Jean-Pierre
De Saedeleer, gold
ring, with
diamonds and
baroque pearls.

63

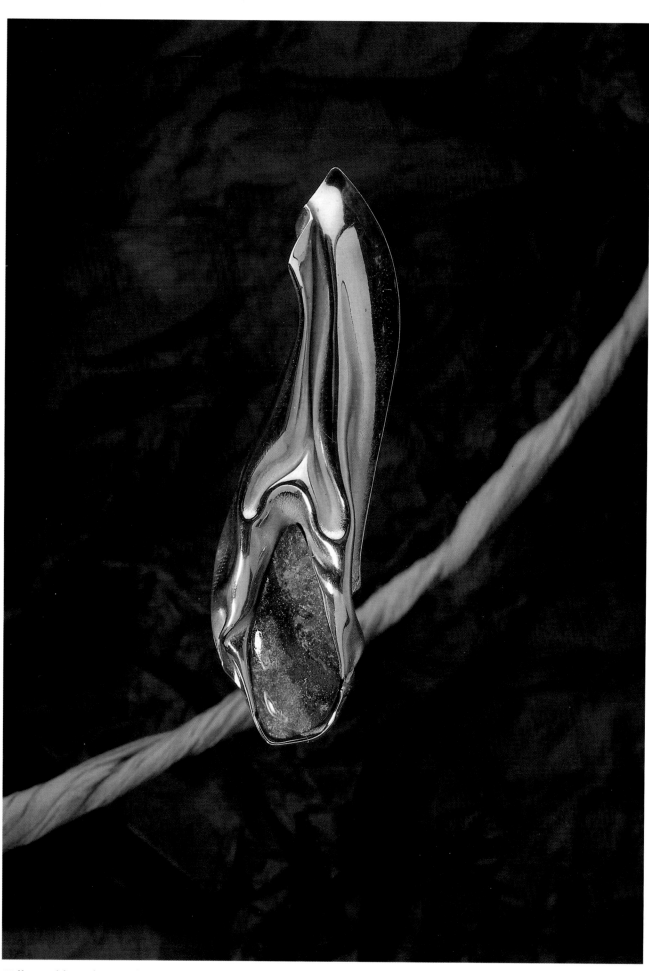

64 *Yellow gold pendant with Australian opal by Jean-Pierre De Saedeleer.*

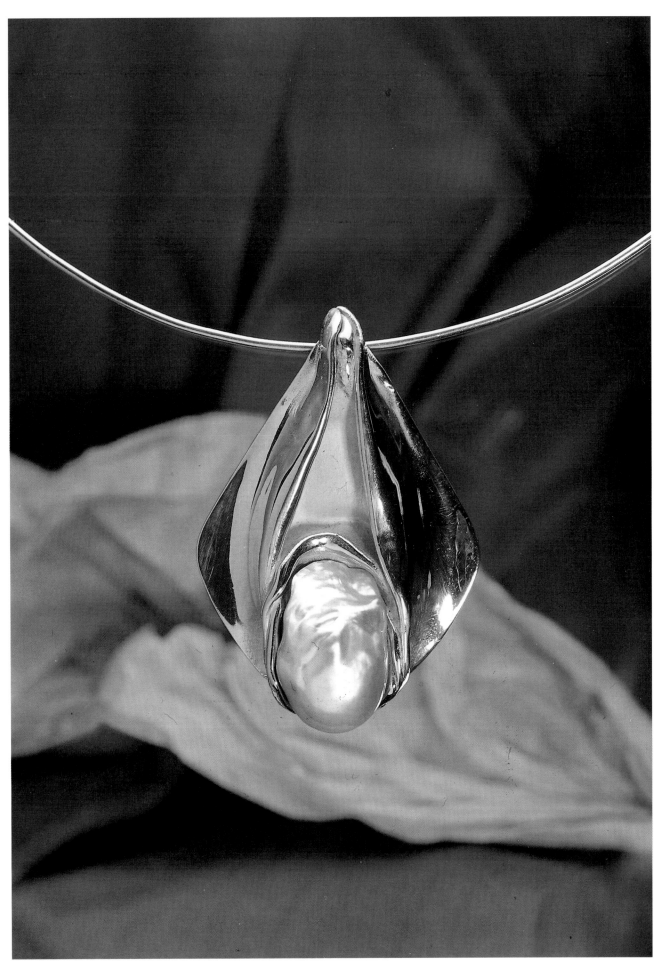

Yellow gold pendant with Australian pearl by Jean-Pierre De Saedeleer.

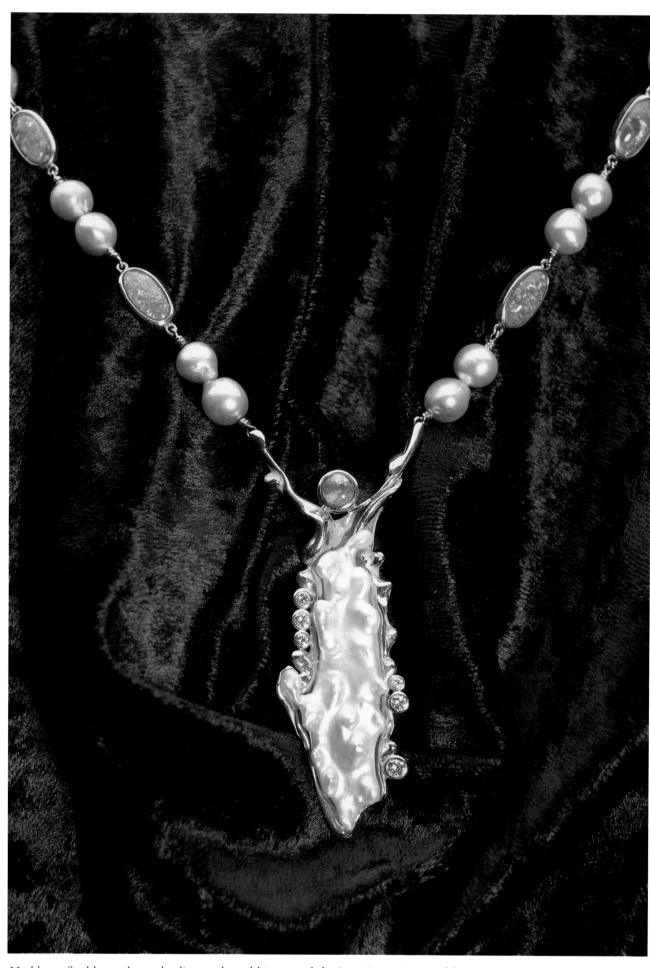

66 *Necklace of gold, pearls, opals, diamonds and biwa pearls by Jean-Pierre De Saedeleer.*

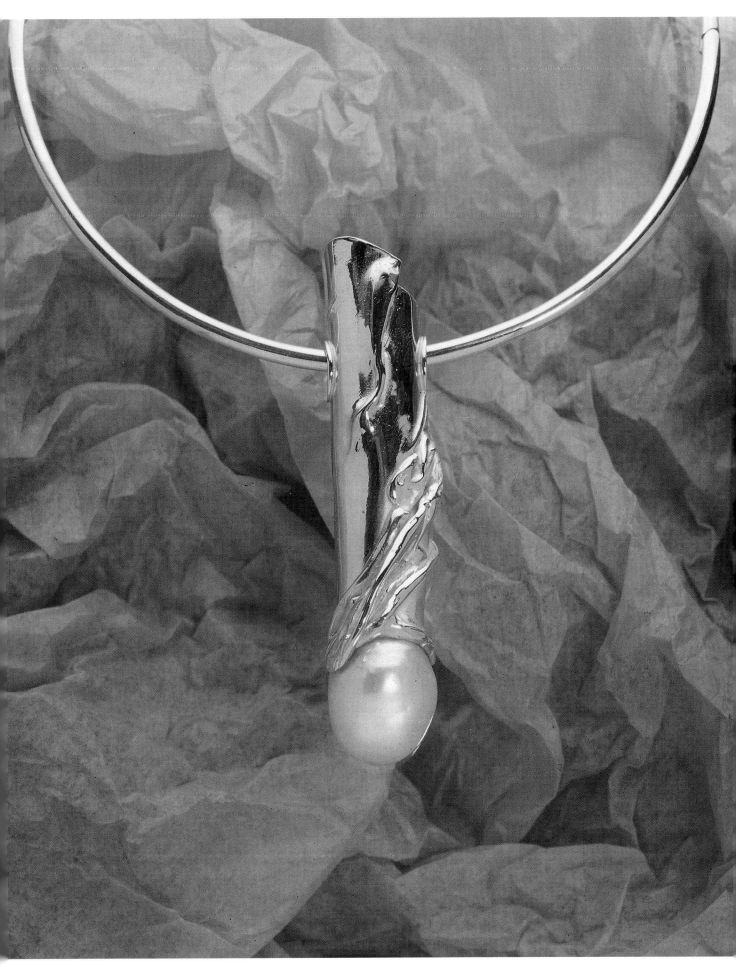

Pendant of yellow gold and Australian pearl by Jean-Pierre De Saedeleer.

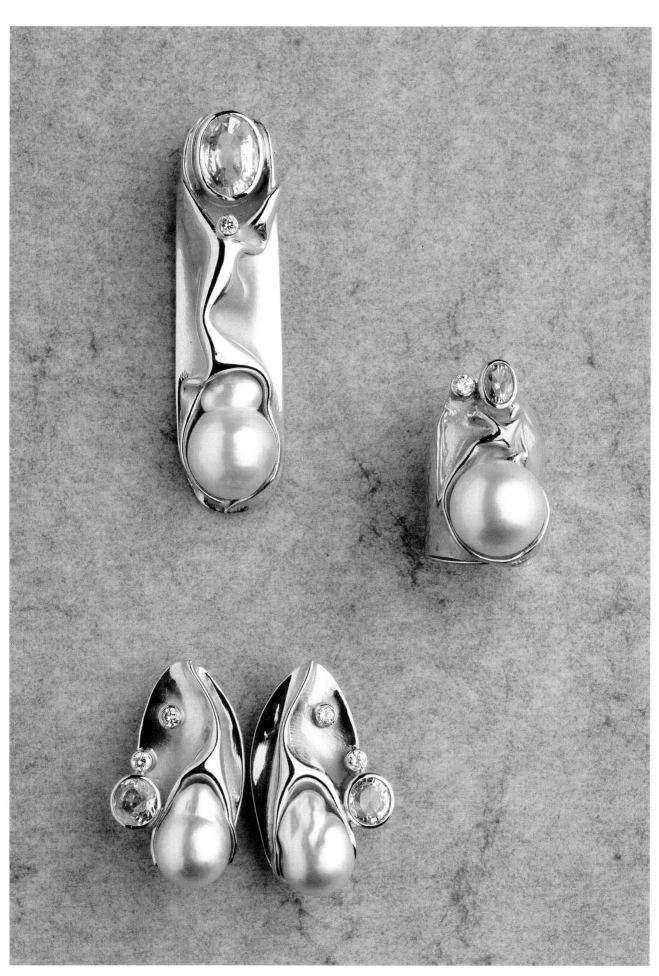

68 *Parure of yellow gold, pearls, stones and diamonds by Jean-Pierre De Saedeleer.*

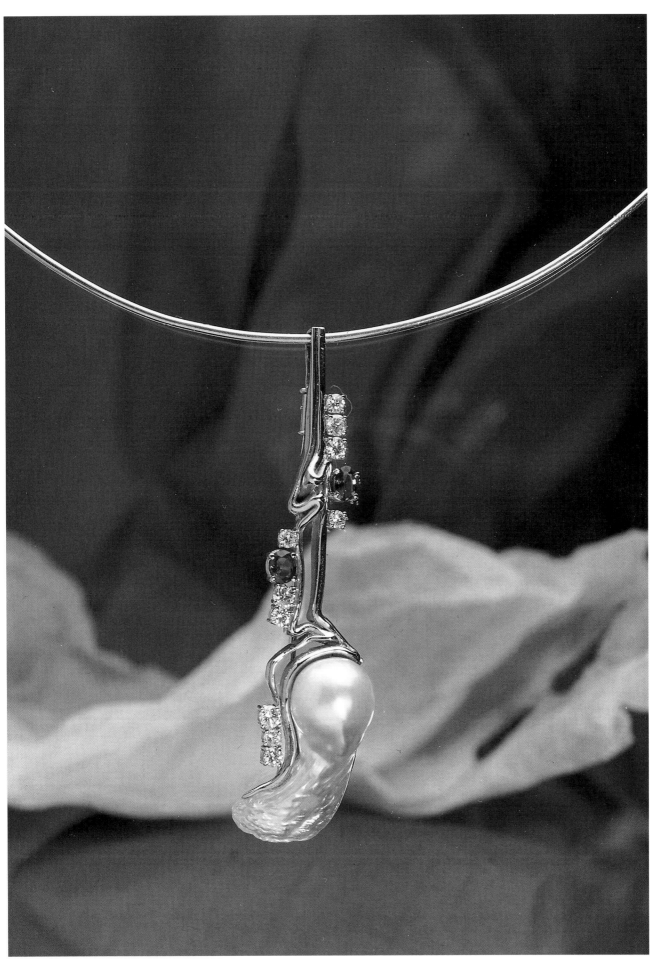

Pendant of yellow gold, Australian pearl, sapphires and diamonds by Jean-Pierre De Saedeleer.

HUBERT MINNEBO

Hubert Minnebo, world famous Belgian sculptor, loves to create huge sculptures in copper and and small pieces in gold and diamonds that he calls wearable sculptures.

Minnebo started creating jewellery in 1975, using gold to transform his monumental sculptures into a miniaturised art form without losing or altering its main features.

Minnebo has a very special relationship with jewellery. He see it as an expression of taste, of good and, for the most part, a singular, matchless work of art, sometimes especially created. This leads to the conviction that a piece of jewellery epitomises creator and wearer, at the same time homage and enhancement.

The creation of a jewel is a way of paying tribute to a woman and Minnebo is well aware of the intimate bond that exists between his works and the person wearing them. A jewel is a personal statement, a privilege and the mirror of its creator. Minnebo's distinctive approach with its frankness and expressive clarity is also seen in his erotic works.

The three pendants in gold, the material he loves best, could not be more explicit or meaningful. Hubert Minnebo's great talent as a sculptor is plain in the singular precision of these works and taken in every tiny detail, even in such small dimensions.

Gold and diamond pendant by Hubert Minnebo.

Gold pendant by Hubert Minnebo.

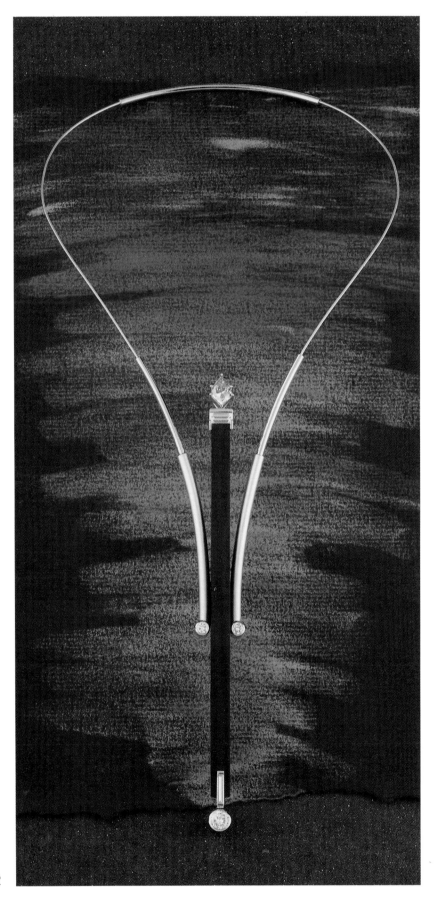

When he creates a piece, Hans Schindler concentrates his attention on the woman who will wear it. "I am particularly fascinated by diamonds, platinum and gold and love to transform them into objects that can reinforce a person's energy. Jewels must first of all set off the personality and make the most of the sentiments of the person wearing them," declares the great designer from Soest.

His work is marked by a great simplicity of lines and the extreme legibility. Some of his jewels seem to say "I love you" and others "I want you."

The colour of the gems and the sparkle of the diamonds fire Hans Schindler's inspiration. The many exhibitions in which he has taken part have showered him with awards and recognition of his talent.

*"Sensual Night",
necklace of gold,
platinum, black
agate and diamonds
in various shapes.*

JAN VANSCHOENWINKEL

"When I think of a new creation, my thoughts initially centre around the materials I am planning to use and the various mineral and precious stones that will be incorporated. Later on my thoughts drift to a character, fluctuating among material, form and colour. I need some time before my pencil strokes first appear on a blank sheet of paper and the future creation gradually takes shape. My pieces are often compositions of various materials: glittering and opaque, white gold and yellow gold, black pearls and white pearls.

Each of my creations is a part of me. It is only this idea that gives me satisfaction when my work is done."

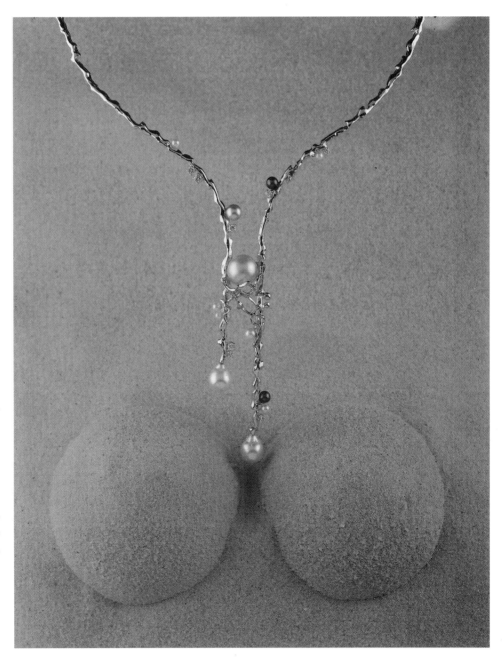

"Erotic arousal always has complex, mysterious connotations. Is it legitimate to trace its origin back to Adam and Eve? Whatever the case, this was my starting point: an apple-tree whose fruit, hidden in a spider web, glimmers through the branches."

Yellow and white gold necklace, entirely decorated with pearls and diamonds by Jean Vanschoenwinkel, student of Jean Vendome and Jean-Pierre De Saedeleer.

ALBERTO ZORZI

Strength and virility as opposed to tenderness and femininity are the terms we need to describe the work of Alberto Zorzi, professor at Padua's "Pietro Selvatico" Art Institute. Aggressive colours and shiny metals whose sinuous forms surrender to the penetration of spinel crystals and Madeira quartz: this artist's jewels can be considered small, wearable sculptures, or simply beautiful objects to admire in a show case.

Yellow gold brooch with ruby spinel, horn and mother-of-pearl. Gold ring with Madeira quartz.

ELIAS A. SAYEGH

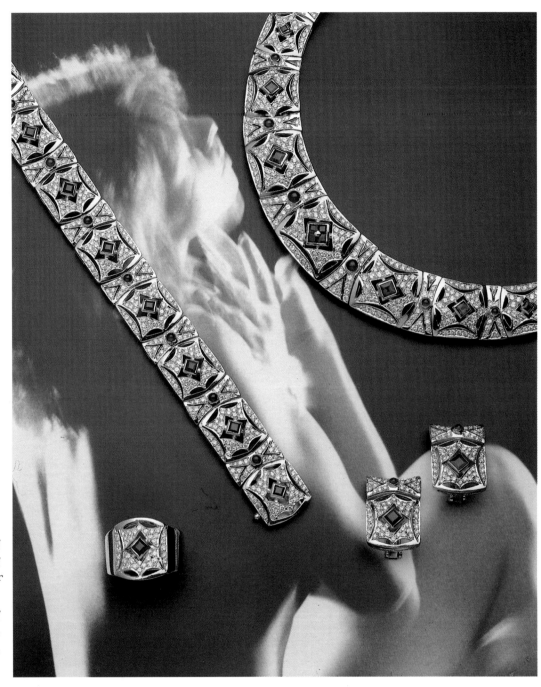

Parure of gold, diamonds and sapphires created by the children of Elias A. Sayegh, Antoine and Ayoub, who carry on the family tradition.

*R*efined taste; an oriental style nurtured with spirituality and brushed by a touch of the West. A tradition perpetuated from generation to generation which will always mark this family whose very name – Sayegh – means jeweller in his native Lebanon.

The reawakening of sensuality through the greatest elegance, achieved through an ancient rite that knows how to spark that desire sought at the moment when the jewel is born. Its non-erotic form sets off the attractiveness of the person wearing it, thus carrying out in full its function as catalyst.

75

VINCENT JAUMIN

In order to express his opinion of the bond between diamonds and eroticism, Vincent Jaumin cites a test of the Confrérie des Orfèvres (the Confraternity of Goldsmiths), published in 1513:

"The diamond bestows its strength and virtue on the man who wears it.

It keeps him from harm, from meetings, from temptation and poison.

It also preserves the bones and the limbs.

And distances him from anger and lewdness.

It brings wealth to those who wear it in valour and good-heartedness.

A diamond is useful to keep for those who are lacking in spirit and as a defence against enemies

For he who wears it will love God even more.

It will preserve the seed of man in the womb of his bride, it sustains the infant and protects its limbs."

Pendant of gold and black Tahitian pearl by Vincent Jaumin.

BATIA WANG

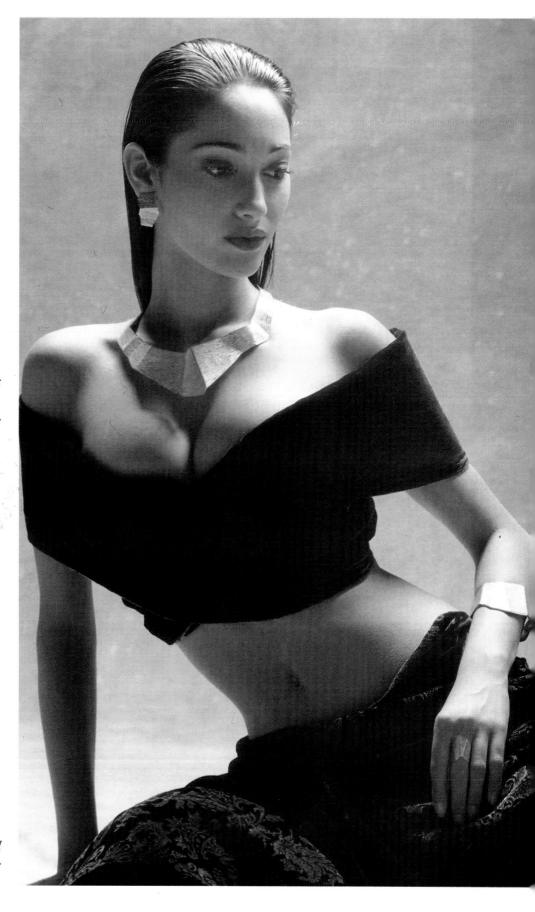

*F*rom Samarkand to Tel Aviv, via the Vienna academy of the Fine Arts, Baita Wang has always lived for art. Her numerous one-woman shows in Vienna, Monaco, Paris and Salzburg are testimonials of her immense talent. Her very personal technique is to create reliefs directly on the metal with fusion or any other procedure using heat. She makes pieces for a number of leading figures, including the family of the Israeli president, Herzog. International critics are unanimous in proclaiming her work "sensual".

*Yellow gold
"Sensual", parure
by Batia Wang.*

*L*ines that cross and weave together, curves that penetrate and vanish, forms that spark a wandering imagination – Michael Good has managed to express desire and sensuality in the play of his golden threads.

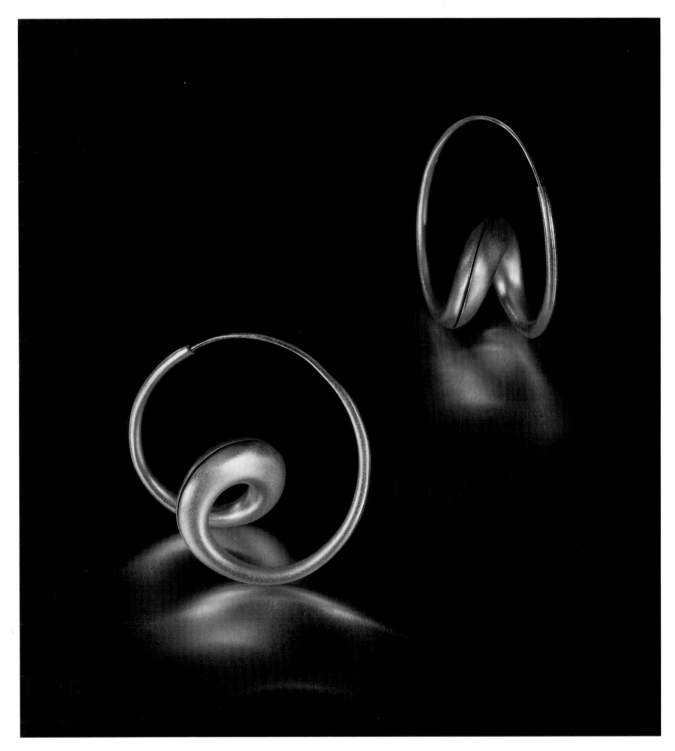

78 *Gold earrings by Michael Good.*

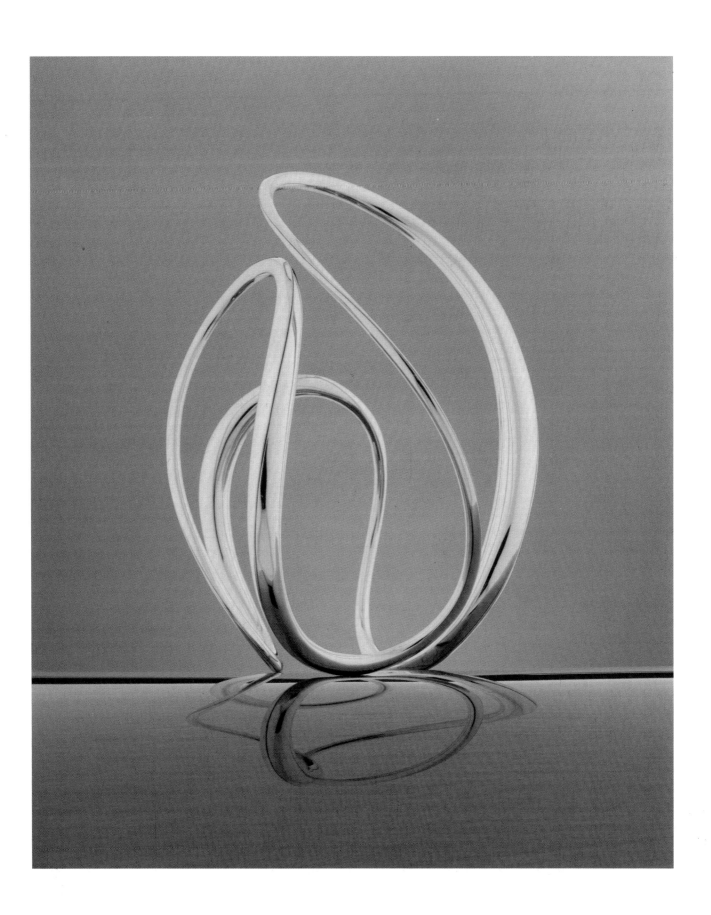

ANNA CELLA

Designing sensuality through curves that recall the human body is one of Anna Cella's specialities. Her jewellery reflects the memory of ancestral shapes tied to the lines and volumes of the human body. The motifs expressed in these tiny sculptures give birth to a spontaneous, immediate desire to wear them.

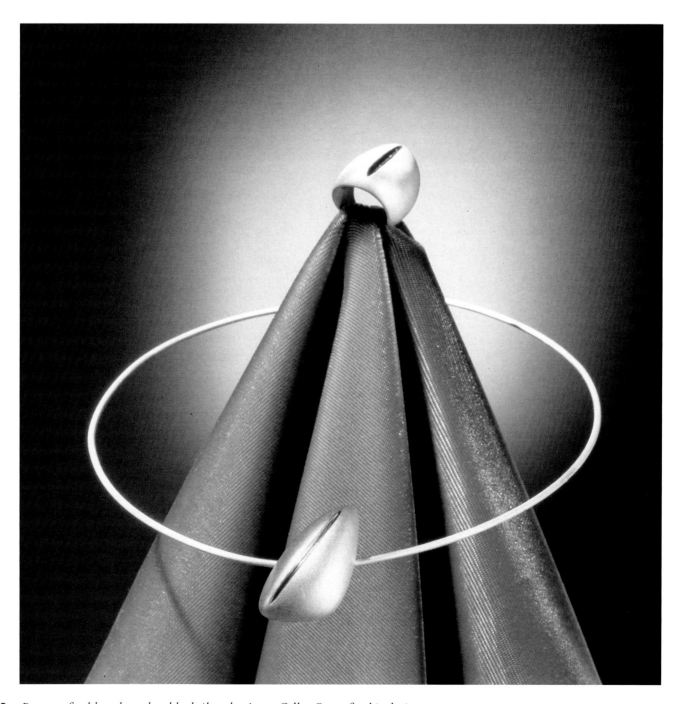

Parure of gold and sand-rubbed silver by Anna Cella. One-of-a-kind piece.

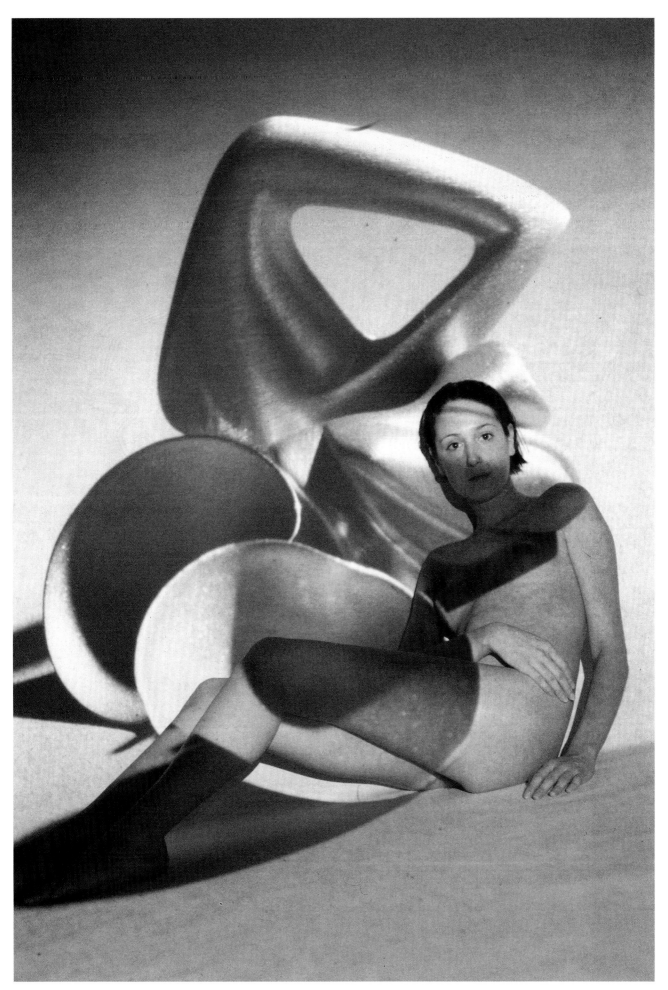

JUSSARA CARACANTE

\mathcal{T}he original jewels created by Jussara Caracante translate the fragility and elegance, the beauty and charm of a great woman. Her necklaces are the fruit of innovative design in which the clasps are an important element, giving them charm and originality from any viewpoint .

The ring mounted with a cultured mabé pearl, with moveable wings made of round diamonds placed on a triangular base, is a symbol of feminine strength and vitality along with her eternally gentle, youthful nature.

As to the "two-faced" earrings, the elimination of clips introduces a new three-dimensional effect that does away with the traditional concepts of front and back, creating a uniquely harmonious effect.

Ring, necklace and earrings of gold with 29 mabé pearls and 22 carats of diamonds, created by Jussara Caracante. 83

GIUSEPPE TROISI (ILIOS)

"*L*oving, as Eric Fromm said, is an art. Art is love, and Ilios is an expression of this type of love.

A jewel can be as cold and inexpressive as a face closed to love. But it can also light up as if flooded with passion. Nothing can be more silken or softer to the touch than gold, its only equal being the feel of a lover's skin as you brush against it. And the flash of a gem is like two eyes meeting in understanding.

Ilios is a design but it is first and foremost the expression of feelings. It is born of the desire to penetrate objects that are already precious in themselves with an inner fire, giving them a soul. It binds the ruby's sombre splendour, the emerald's lofty allure, the sapphire's magic flow and a diamond's lucent shivers and harmonises them with the pliable metal. Ilios is the result of careful study carried out with enthusiasm and faithful devotion. It is the adventure that comes with the love of fine jewellery.

Ilios is a group of master goldsmiths. It has two locations, one in the throbbing heart of the Eternal City, next to the alleyway where Cellini created his masterpieces. Today, as always, Ilios uses the same techniques that craftsmen have passed down through the centuries. The objects they produce are unique, forged with love because the object of our love is unique indeed.

This brief presentation is accompanied by photos of some of Ilios' designs. Particularly striking is the refined line of the brooch, with its meticulously chosen stones and materials that perfectly embody the caramel colour of honey and the busy bees. There are also rings with lively shapes and coral with its timeless charm. And each and every piece completes and enhances the beauty of the woman wearing it.

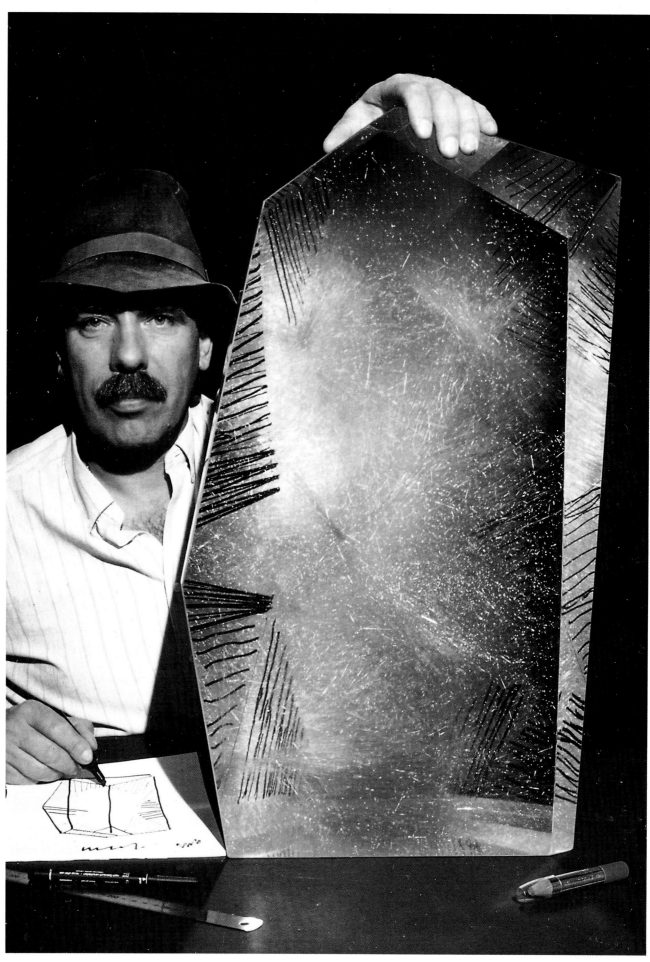

88 *Bernd Munsteiner, creator of jeweller and stone-cutter working at Idar-Oberstein, Germany.*

THE SYMBOLIC

In collaboration with Bernd Munsteiner

In German, Munsteiner means "moon stone". Bearing the name of a stone is a unique destiny and a auspicious gift for a jeweller of his standing!

Bernd Munsteiner, universally recognised for having revolutionised the art of stone cutting, was born in Germany in the region of the agate mines, in Idar-Oberstein. Today the city is known all over the world as a centre for cutting coloured gemstones.

The descendent of a dynasty of lapidaries, Bernd Munsteiner is renowned for his inventions of extraordinary cuts. He is the creator of numerous works adorning the cabinets of museums and important collectors all over the world. His prodigious ability to converse with matter has earned him international acclaim. His latest discovery, the authentic zenith of all his efforts, is a form that was suggested by the Vedas, the ancient sacred texts of India. Guidor Rigdor explains how Bernd Munsteiner reached this new pinnacle of his art.

THE "SYMBOLON"

Creations by Bernd Munsteiner inspired by the Veda's eternal knowledge.
In the field of gemstones renewal is difficult. Even though his discoveries are based on documents as ancient as the Veda, no one except Bernd Munsteiner could have given us something really new.
It was Munsteiner who first pioneered creation in the field of stone-cutting and it is only fitting that he should undertake to tie it to its origins. He has closed the circle with his latest invention: the "Symbolon" cut. Symbo… what? A legitimate question, even if the word itself alludes to part of the project symbol, therefore, essentially, a revealing signal for initiates.

A "Symbolon" cut by Bernd Munsteiner is a perfect, perfectly finished stone, a symmetric whole based on one of the most basic, archetypal forms known today.

When you touch the stone you penetrate it completely, and any designer incorporating it into a piece of jewellery will have to fashion a counter-harmony to encompass the "Symbolon" within the creation.
It is impossible to add or remove anything: the "Symbolon" is a unique, untouchable dimension, like a given fact. Then, and only then, will it be possible to balance it with a personal design that allows the realisation of that counter-harmony essential for acceptable balance.
Just what is it that inspires Bernd Munsteiner?
What gives him the authority for such categorical pronouncements?

The first flash of inspiration came to him while visiting a friend who owned a collection of sacred stones called "Siva Lingams", archetypal forms which, according to the *Veda*, contain the whole of creation. The name "Veda" comes from Sanskrit, originally the word "vid" which means knowledge. By *Veda* we mean a series of natural laws which can be tested according to 89

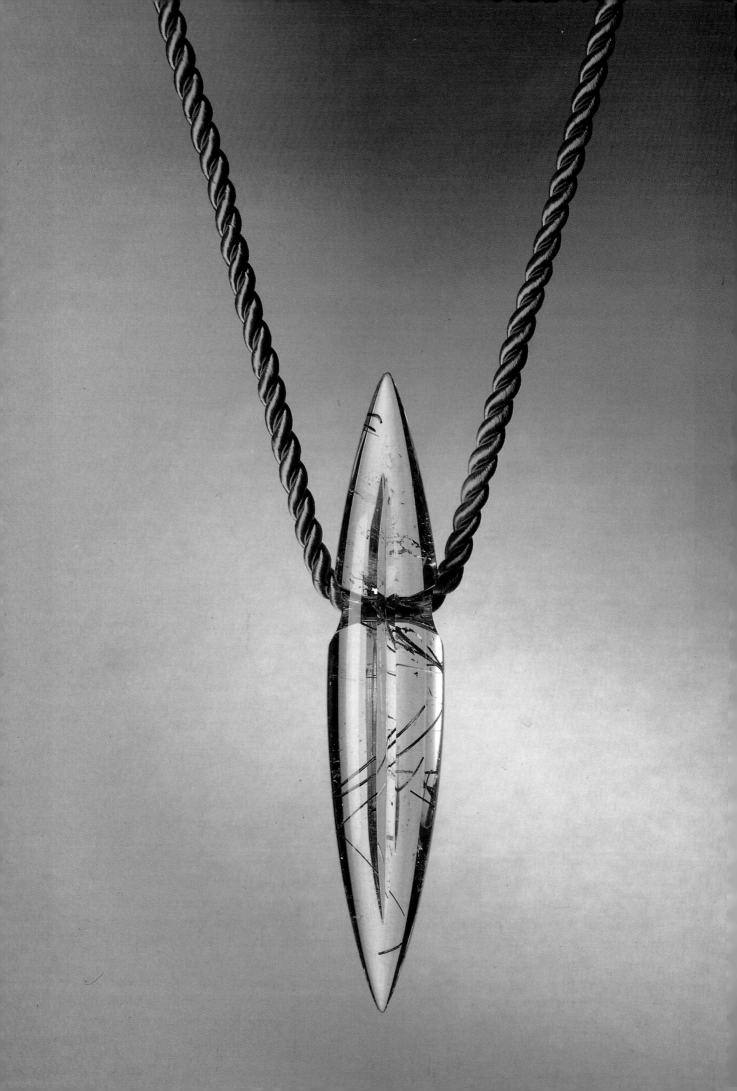

Different "Expressions" of the "Symbolon" by Bernd Munsteiner.

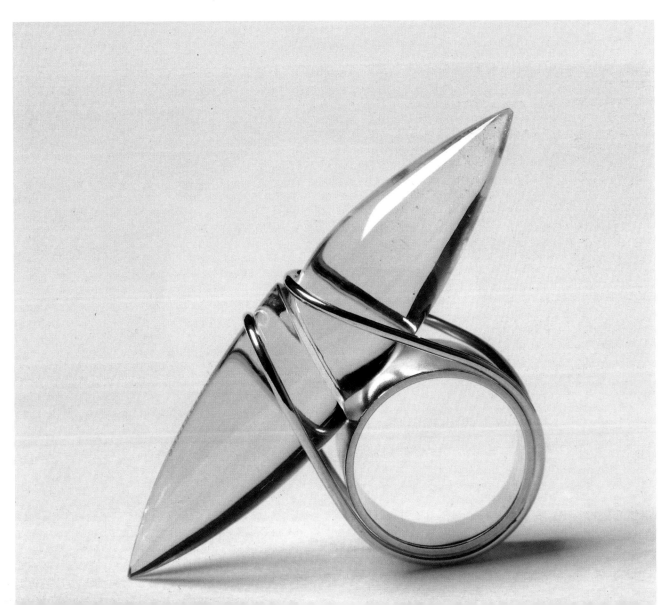

91

our level of knowledge. Some have attempted to transcribe these laws; attributing meaning to the written word. In the Linga Purnana, part of the *Vedas* (Chapter 46, verses 11-13), it is written:

"… the entire world is identical to Linga. All is based on Linga… ."

It is not easy to understand why the form of the Linga is circumscribed in such detail – an experience subsequently confirmed by these stones. If you caress one of these sacred stones, you are left with the same feeling of tenderness that you feel for a newborn. That is exactly the feeling Bernd Munsteiner expresses with his concept the "Symbolon". In his previous work, the sculpture in particular, the artist played with a series of metaphors. The phallic "Symbolon" crops up repeatedly throughout his work where Munsteiner tries to combine the male element (the phallic symbol) with the female

(the symbol's negative reflection) in one single, buoyant creation.

There was a remarkable change in Munsteiner's work after the impressive "Symbolon" collection; the male and female elements were no longer associates. Now they were united. Munsteiner ceased to create an assembly of two opposing forces and the "Symbolon" is a preparatory field for pre-opposition, the integrity and unity of opposites before underling the duality, which is at the base of this creation and at the base of its fundamental truth.

Bernd Munsteir instantaneously added a female element to the initial male element. The "Symbolon's" oblique, multi-dimensional oval form is a painstaking description of the unity on which the creation of the Siva Lingam, so common in the Vedas, is based. These are not two parts conceived and joined together, but separate. They make up a whole

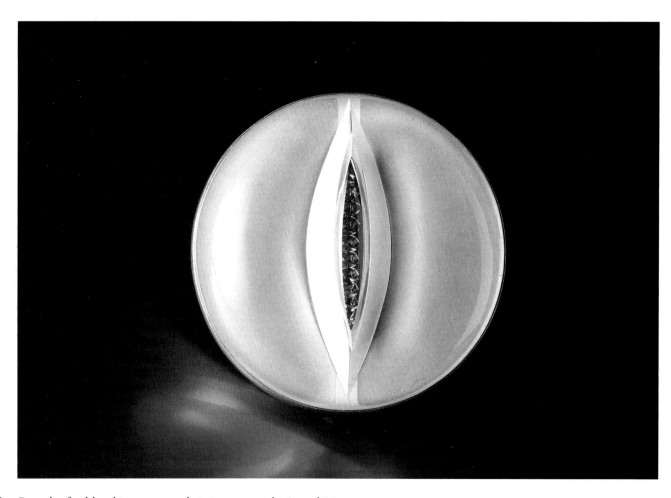

Brooch of gold, white agate and citrine quartz by Bernd Munsteiner.

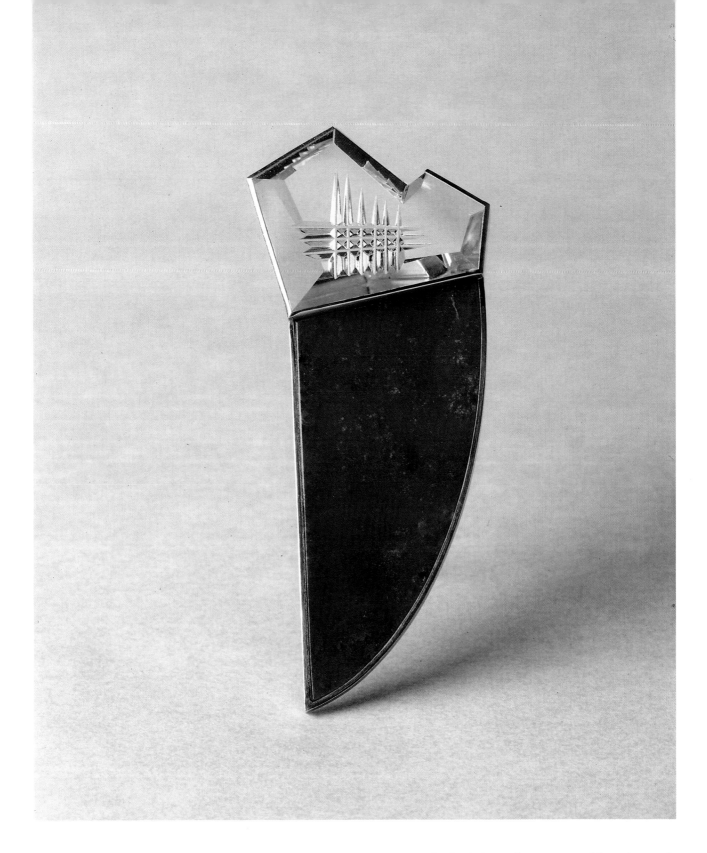

wherein the principle of beginning is manifest, captured in the first phase of the conception. Thus we are given a visualisation of the design at the creator's conscious level. Bernd Munsteiner is already recognized for his countless "innovations" in the field of stone cutting of which he is known world wide, and for which he has received international acclaim. His latest creation – the discovery of an archetype that symbolises the origin of any kind of pattern, the mother of all created forms – is the peak of his career.

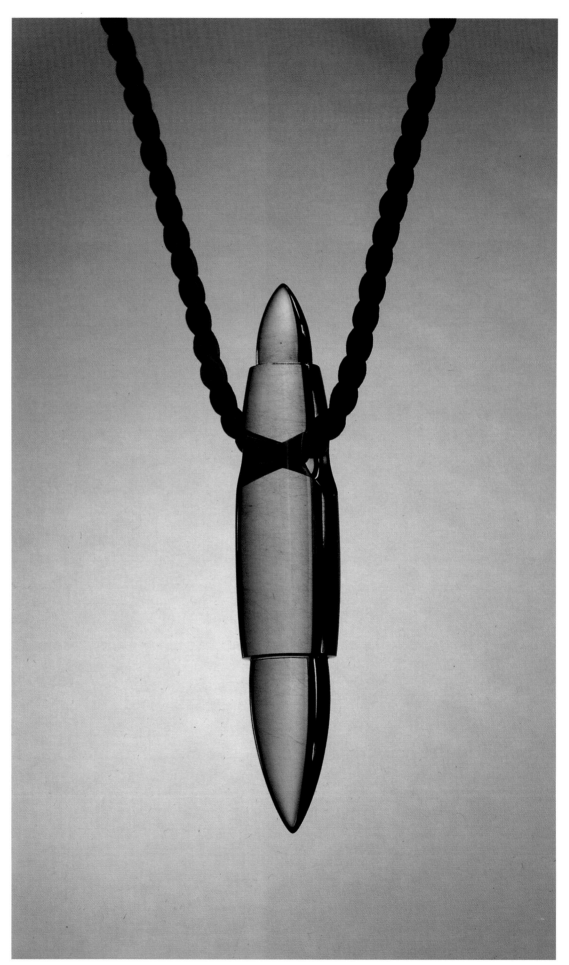

94 *"Symbolon" pendant in smoky quartz.*

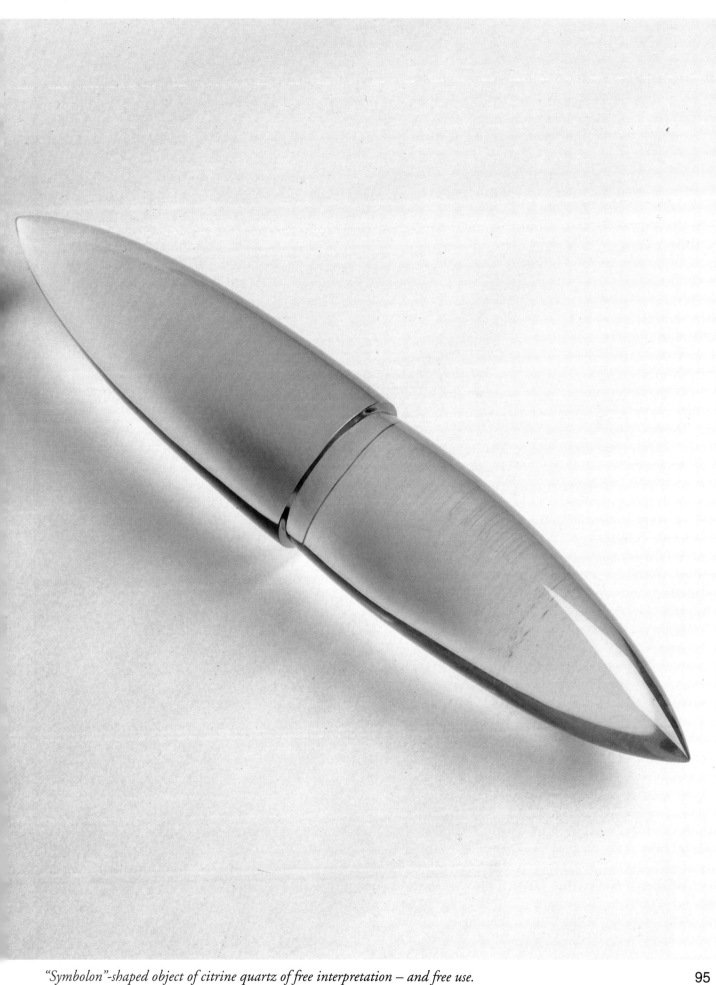

"Symbolon"-shaped object of citrine quartz of free interpretation – and free use.

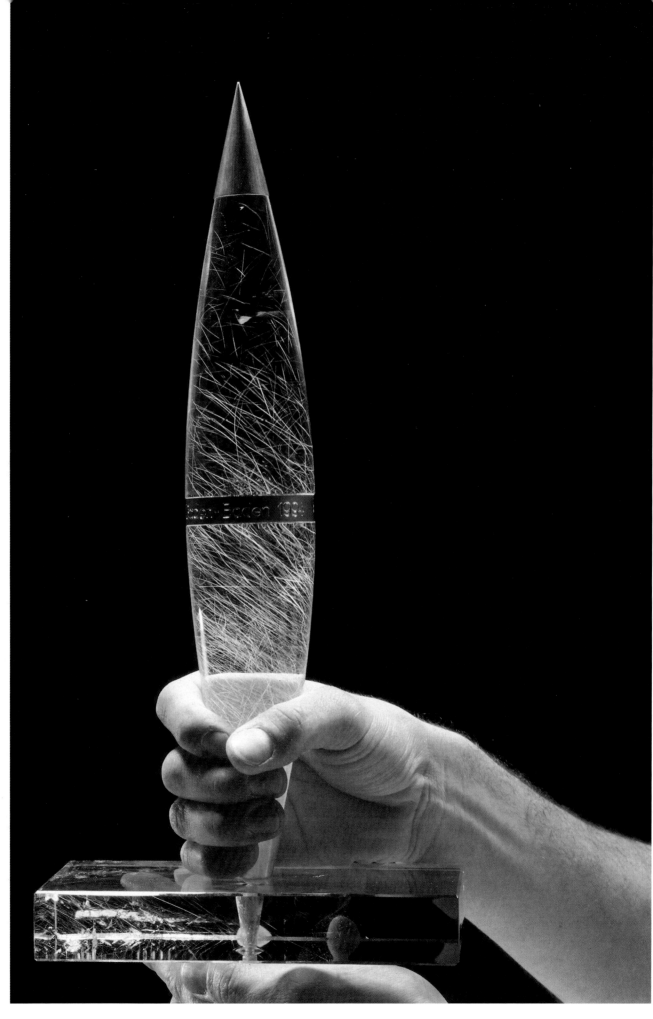

96 *The "Fritz Walter DFB 94" trophy is a "Symbolon" styled in red quartz or angel's hair.*

Symbolic objects by Bernd Munsteiner: Gold brooch, with ruby, and citrine quartz. Gold brooch, with agate and aquamarine. Platinum and aquamarine brooch.

"Breast", brooch of gold, platinum and Spirit Sun-cut diamond. Creation by Jörg Munsteiner.

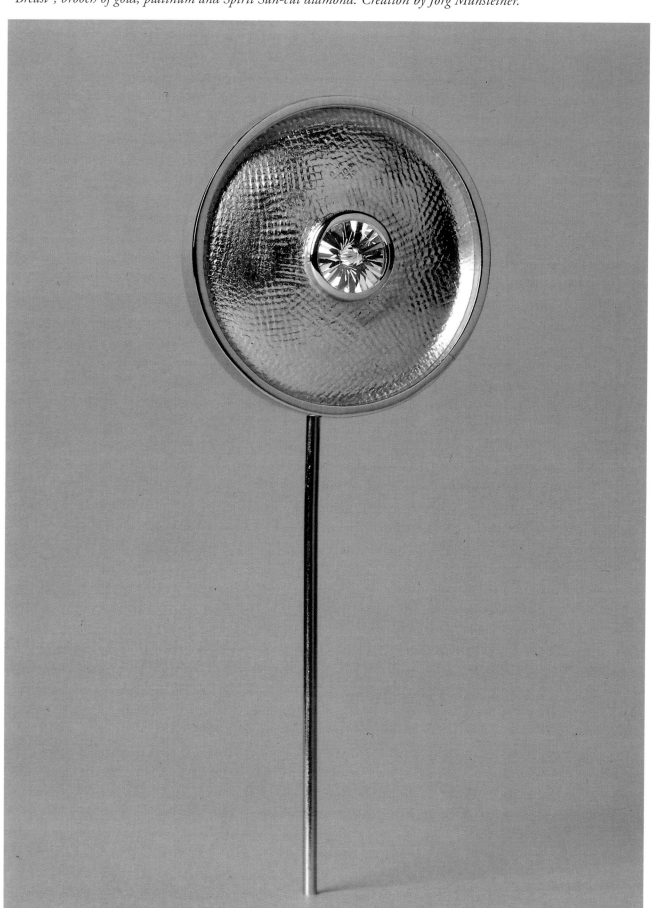

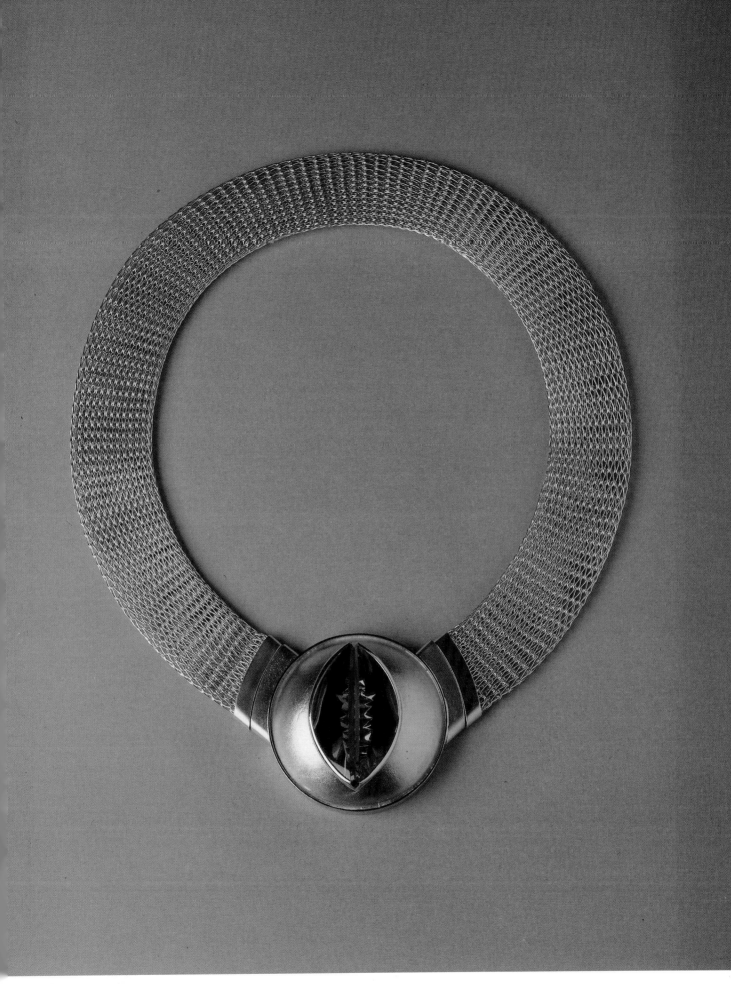

"Origin", woven gold and citrine quartz engraved by Jörg Munsteiner.

TIZIANA AND MASSIMO ALOISIO

Tiziana and Massimo Aloisio unite their efforts and talent to blend sculpture and the creation of jewellery in a single work. These two great artists have created new symbolic lines that speak for themselves. From wax model to the final ornament, their close cooperation, their close cooperation is in the purity of form and is exemplary of a perfect osmosis, reflected.

Gold ring representing Yin and Yang.

"YIN AND YANG"

Yin represents the female principle, Yang the male.
In other words Yin represents also, all that is round and flexible and can be symbolised by all that is dark and humid. Yang is that which is hard and rigid.
It can be depicted by all that is light and shiny.

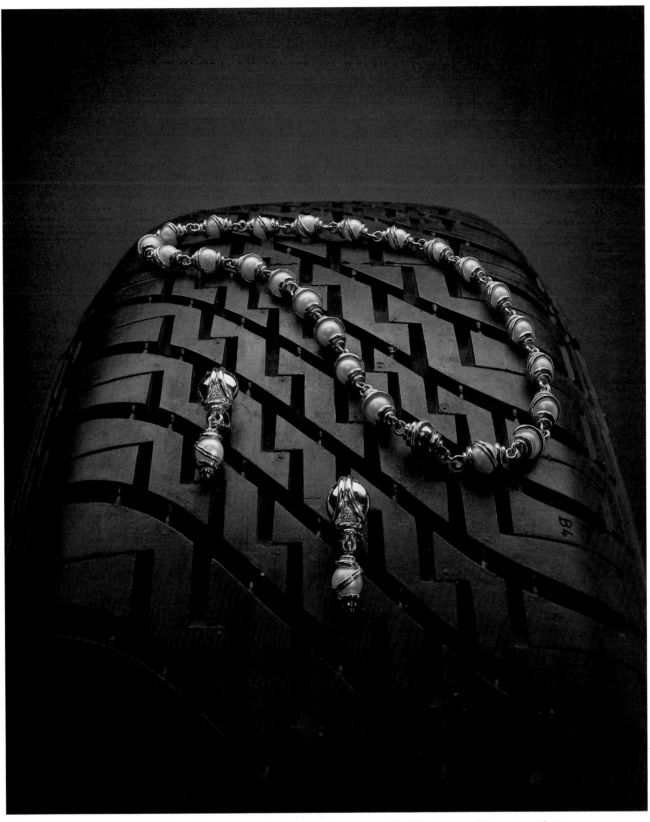

Yellow and white gold parure with diamonds and pearls by Tiziana and Massimo Aloisio.

"THE WHEEL OF LOVE"

Gold is the masculine symbol of strength.
Pearls are the feminine symbol of refinement.

The wheel that pulls them in the perpetual movement of love.

GEORG SPRENG

"*K*iss Me" is the name of one of the platinum brooches designed by Georg Spreng. Truly a creator in every sense of the word, Spreng loves to isolate himself for several months at a time in the icy forests of Canada. He lives there in a simple hut, in primitive conditions without any of the modern comforts. During these periods of absolute, what we might call ferocious, meditation he finds the inspiration to create his huge, meticulous masterpieces when he returns to Germany. "Each and every one of my pieces," says Spreng, "is first and foremost of erotic inspiration."

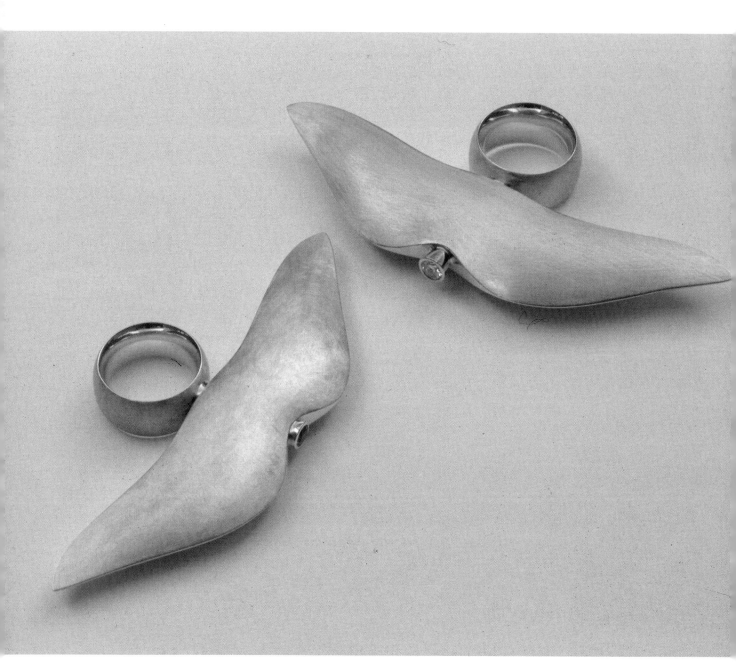

Two "Kiss Me" rings styled in gold, diamond and ruby.

Above: *Georg Spreng during his "primitive" period in the Canadian forests.*
Below: *All the difference between a cold mouth and a warm kiss is encompassed in the contrast between gold and platinum. Two brooches that seem to beg "Kiss Me", suitable for both men and women.*

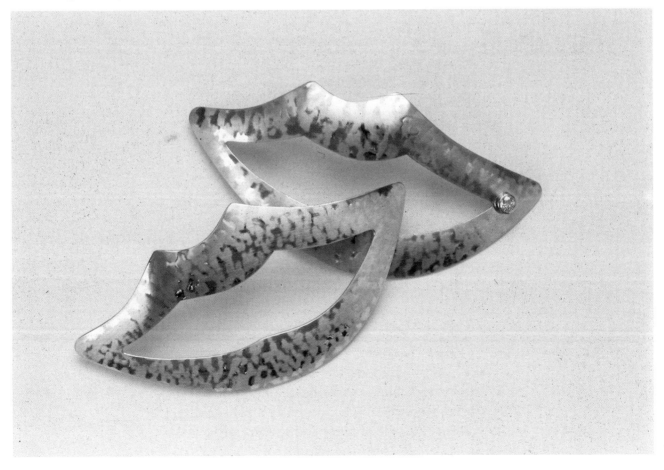

WOO-HYUN CHOI

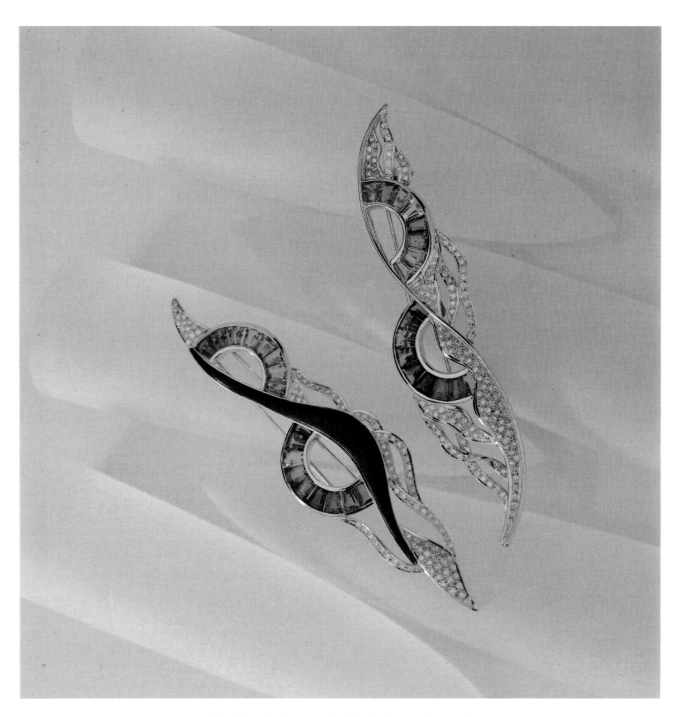

*"Sky Travel". Brooch of gold, platinum, diamonds,
tourmaline, topaz, amethyst and rhodolites.*

*P*ositive and negative, man and woman, a
contrast in colours in a single, long, rounded
form. Woo-Hyun Choi proposes a pairing of
colours, a tangle of types and the free orbit of
his imagination.

GILL SEGI

A creator specialised in the design of a multitude of forms, Gill Segi presents a magnificent coral necklace of the colour of love. In the centre lies a nude woman, resting on a fig leaf.

Gill Segi is known for her originality and her interest in the erotic universe.
This can even be seen in her signature: she loves to include the form of a tiny spermatozoid.

The ring of love and the bracelet made of coral and yellow gold are the symbols of heterosexual relations.

WILLIAM GERMANI

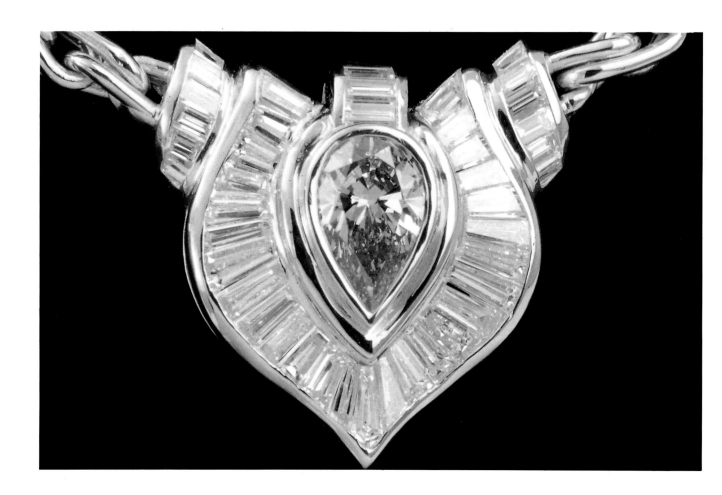

*H*alfway between abstract and representational art, this highly viable necklace shows us – with great imagination – Eve's best-kept, most coveted secret.

William Germani, one of Lebanon's most important jewellers, has created an intimate blend of luxury and lasciviousness in a classic jewel that is a precious, refined message for those initiates who know how to read it.

HENRI GARGAT

*S*hell? Plant? Fossil?
Perhaps it is simply a return to origins, an elevation of thought towards the infinite. Better yet, maybe it is the creation of an intimate part of the female body and its close relationship to the psyche.

The world famous Henri Gargat has united man's various obsessions in this one of a kind piece.
The female sex is an eternal unknown, a question mark that always extends itself further over time until it is lost in space.

MARCELLO PIZZARI

*M*asks symbolise the unknown, the hidden, the mysterious. This has been so since ancient times in tribal cultures when they were reproductions of the countenance of the gods. It was true for royal banquets where guests came incognito. And it was true up until the Carnival, where masks were a basic part of masquerading. Eros is like that: it is discussed, explained, commented upon or defined but there are no absolutes. Every human being has his or her own form of eroticism hidden behind the mask of consciousness.

"Dream". Mask-brooch styled in gold, diamonds and gemstones of various colours. One-of-a-kind piece by Marcello Pizzari.

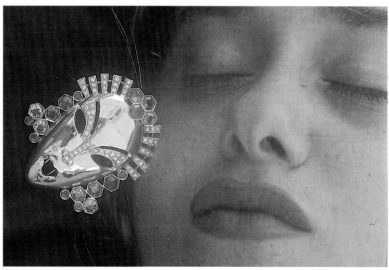

GABRIELE WEINMANN

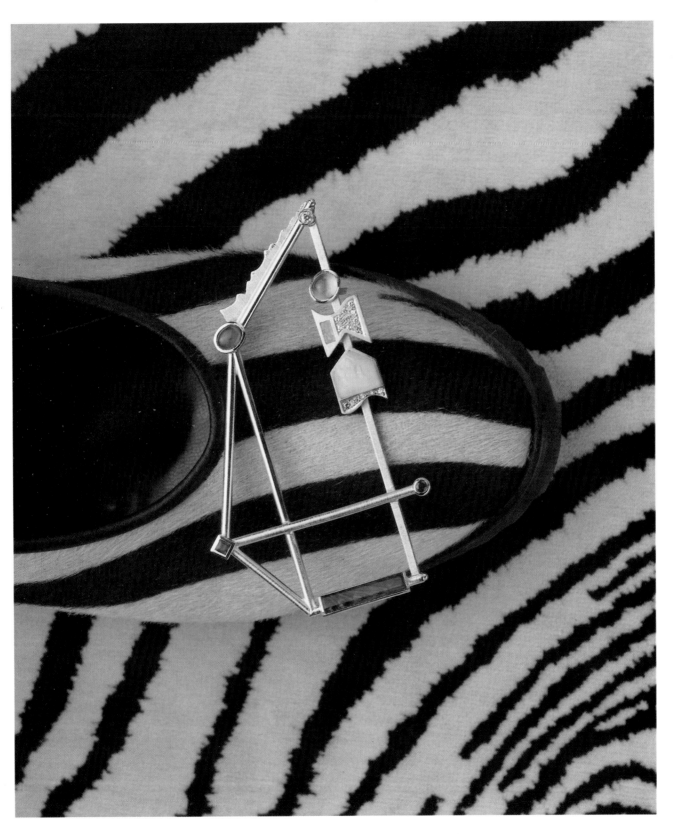

Paul Eluard in "Capitale de la douleur" said:
"Petite table, je n'aime pas les tables sur lesquelles je danse, je ne m'en doutais pas."
Earring or pendant of gold, blue and white diamonds, ruby, tourmaline and opals by
Gabriele Weinmann.

Enrico Pinto, professor of jewellery, creator of jewels, painter and sculptor in Rome.

THE PHILOSOPHER

In collaboration with Enrico Pinto

This is the philosophy of painter Enrico Pinto concerning the relationship between eroticism and the creation of jewellery.

"Eros: its uniqueness lies in its being a real event, an experience you live, not one you depict. If that is the case, then the question is: what sense is there in attempting to represent Eros through language?
"The result would be a deception, a hoax, definitely inferior to reality, particularly since it is a reality that touches everyone and is therefore grasped by all.
"By its very nature, a work of art actively suggests ideas within reality but that is, in this case, a useless criterion unless the representation contains a spark of creativity's innate sensuality.
"Sensuality is one aspect of Eros not necessarily identified with sexual intercourse which is a part of normal human sexuality. Eros as seduction, eroticism, sensuality, and even pornography, is a spiritual event in human culture and therefore a narrated event.
"Sensuality on the other hand is a life experience which moulds this event through its own means of expression.
"I therefore believe that Eros, eroticism and sensuality must be understood in the same way that we understand the materials and techniques professions use.
"By establishing this type of relationship, Eros is displayed in a work because it carries with it vitality, intellect and freedom. The subject, like the topic itself, contains allusions for the user.
"Given the universal nature of sexual intercourse, Eros is present in human cultures as a striving for the absolute. Sensuality is a way of perceiving the world's reality. It is a condition, a state of an experience reached. It is a new reality that abandons set ideas as it passes from the natural sexual act through culture. Sensuality lives in the present, free of possessiveness and, consequently, evolves into a new culture. Sensuality is the need to incorporate, to merge with the other. It is a spiritual event and as it takes place, it creates, thus presenting and not representing. Only this process can justify the making of jewellery.
"I think that of all goldsmiths, he who was most successful in following this path and presenting the theme of Erotic Jewellery was an illustrious ancestor named Zeus. After all, it was Zeus who transformed himself in a cloud of gold, entered and 'fused' with the body of Danae, fecundating her and thus generating Persus. Jewellers should be proud of this myth but they should also be a little worried because this way the relationship between gold and life proves to be more demanding than usual. In this true-to-life symbolism of its value, the gold that flows in the body of Danae is a particularly generous element. It has to adopt the body's softness to unite with it and be creative.
"More than any other metal, gold can express our physical, psychic and spiritual qualities. I think Lévi-Strauss was quite right when, in keeping with the myth, he pointed out the importance of jewellery from an anthropological point of view as something born of the 'need to defend the soft parts of the human body.' This is the way gold must be perceived in order to have a sensual

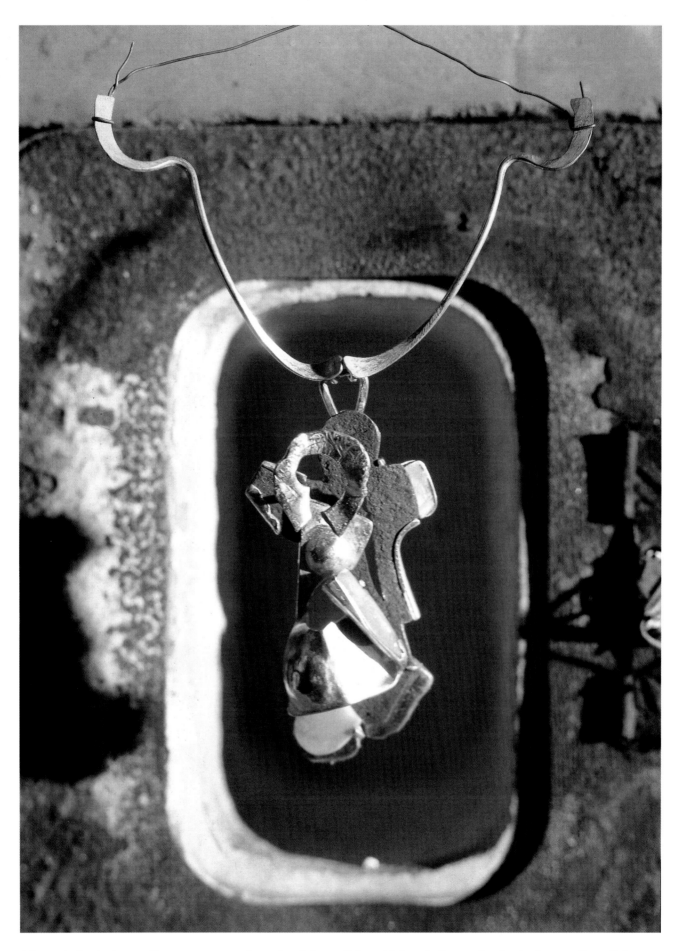

Through the darkness of its empty space, the sculpted form of the gold female figure absorbs the iron outline of the man. This creates a dialogue between light and shadow, opacity and luminescence, an absorption of the parts that make up the image as an apparition. From the dark to the light as continuity.

112 *Necklace of gold, rusted iron, silver and coral.*

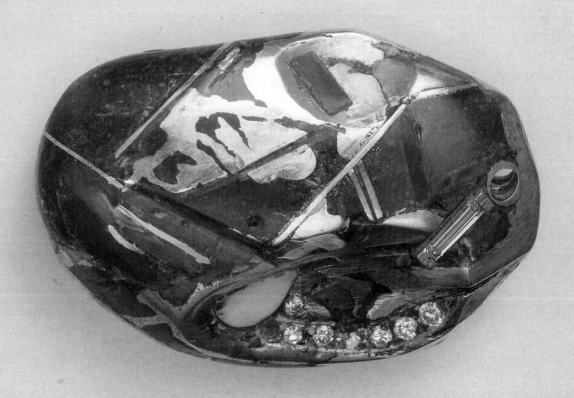

relationship with it, to present it as Eros and represent it as eroticism through jewellery.

"So what can a jewel be?

"Even given the proper proportions of size, it is certainly neither sculpture nor painting nor architecture

"It is an object that belongs to it is not extraneous to it our body. The request – often born of an inner need – and its use, is different from the production of other arts. So, as a result, the ends of the material used are different as well. It has a symbolic-gestural language all its own.

"There is a purpose that unites the creator, the purchaser and the one who chooses or wears a jewel. The fact that it is worn also creates, through the curiosity and the unexpected generated by every work of art, an intimate understanding and involvement of the physical relationship. It is a physical witness of other realities and aspirations; that of an intimate friendship based on a secret that is actually a marriage of sensuality and display.

"In essence, this public display of the jewel as an ornament is freedom from modesty, rather than its repression or elimination. Recognising the jewel as a necessary adornment because it is an ornament – metaphorically speaking – fulfills the aesthetic nature of the man who is able to incorporate it. It does not adorn the subject, it is the subject because it has been shaped independently. That is the only way it can extend and highlight man's inner structure. There is never anything definitive in jewellery, no final absolutes. All that we see are allusions and hypotheses and on this basis it reveals the truth.

"Some aesthetic theories maintain that the ornament is the natural formal conscious development of an initial unformed scrawl, closely tied to the sexuality and sensuality that notoriously arises out of the mystical experience. For others, as Adolf Loos states in his historic essay, *Ornament und Verbrechen*, ornament is crime.

"These theories and attitudes were necessary ninety years ago to free ourselves of the ornamentalism of the Victorian Era. Since then however, another ornamentalism has arisen from those very ideas: the ornamentalism of simplification.

"It is difficult not to recognise that the ideology of industrial art and design, of art for art's sake, the freedom of aesthetics means, the psychology of form and – in the years following the historic avant-garde movement – the need to recreate a relationship with the objective world posed some interesting problems. These arose out of what was one of the basic credos of modern art, postulated by Walter Gropius in the Bauhaus manifesto of 1919, '… An artisan cannot be an artist, but an artist cannot help but be an artisan… we form a new corporation of craftsmen without the class distinction that raises arrogant barriers between artisan and artist.'

"Thus, when this barrier seemed to have fallen, its resurrection under the form of confusion of roles, that has always eliminated the osmosis needed to avoid the depreciation of both in the separation, seemed incomprehensible.

"Craftsmanship was reduced to mere dexterity (caused by intellectual laziness and an accent on technology as an end unto itself). As a result it was destined to almost complete extinction while art – with the refusal of recognising its own historical memory and estranged from operational support – was forced into producing mere decorative abstraction, often losing its ability to acknowledge man's creativity.

"As an attempt to respond to this contradiction that torments our era, there is the conviction that a specific definition of the relationship between specific knowledge of a vocation, its dynamics, the material used and the possibility of creative value, as long as they are indivisible, can no longer be delayed. We might therefore rectify Gropius '… An artisan cannot be an artist, but an artist cannot help but be an artisan…' by saying that it is impossible to be one without the other.

"In addition, we might formulate the

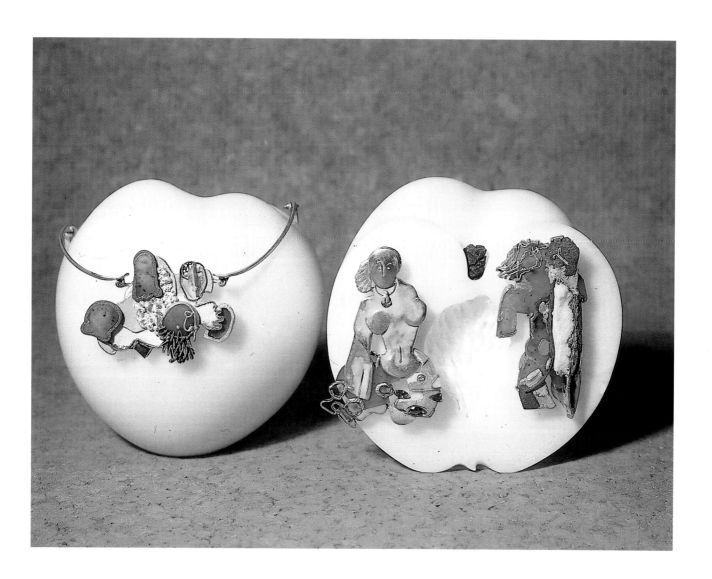

"The Creation of Eve." Eve comes out of a sleeping Adam. Her face, seen both in profile and front, gives the figure a movement of growing independence which repeats the image in rotation, detached and in front of the dormant material, inviting it to awaken. Lasa marble, rusted iron, gold and jade.

"Female Figure". Like a woman's body, the colour sensuality of the world seen in the surfaces of light is inherent in the gold plate of the skirt. Jewellery as a character becomes an ornament on the body of the female figure, a simple, enigmatic play of reality and artifice. Gold, diamonds, rubies, turquoise, alabaster, jade and tourmaline.

"Lovers". Union as cohesion between bodies with its own very special rhythm. Forms continue to emerge until we see the shape of faces surprised in that personal feeling of the culminating moment of intercourse. The two-dimensional effect takes on volume with the mirror-like effect of the faces. Rusted iron, jade, gold, silver, diamonds, blue sapphire and garnet.

All these pieces of jewellery represent the union of opposite forces in the unity of form. They are all subjects tied to Eros: pomegranates, water, fire, erotic games, taboos, pages of the Kamasutra, and so on...

"Danae." In order to better depict the psychological availability and the body's receptivity, the artist uses materials to create a painting-like luminosity, formal zones that communicate rhythmically.
Necklace of Lasa marble, iron, gold, turquoises, onyx, diamonds and emeralds.

hypothesis that now the artist – with the strong perception of a new inner reality born of the aesthetic revolution of modern art – can use these specific tools of his profession in a new way and in relation to new expressive means that are pan of and at the same time suggest, an aesthetic response. "Why cannot all this become an answer to the limitations of today's widespread penchant for decoration as art, a form which is incapable of overcoming the simplistic dimension of taste and current fashion? I am certain that this volume can spark the desire in those who create and wear jewellery for a more vivacious relationship with gold and with jewellery".

ALBERTO GIORGI

" . . . So I think that a woman, a fanciful, sensitive creature is always present in the conception of my work. She is present as a formal instigation, as a mobile material. So my jewellery does not only express a structure, with dimension, form and pertinent, nay aesthetic interest. It must also have a functional goal. Recent artistic discoveries, 'grey-white spatiality, stain white'; thinking machines are psychological jewels because they act on the person wearing them in a positive, soothing and amusing way, freeing her of the imaginative vibrations absorbed every day.

This human projection in my work is no substitute for a study of technology, that attempt to create a new relationship between man and machine. A machine is no tool; it is a being that can grasp, reason, elaborate and decide. It must be capable of reflection. This capacity is expressed and executed in a jewel-sculpture."

118 *"Tarantula", structural experiment by Alberto Giorgi. Gold and silver hairpin with moveable parts.*

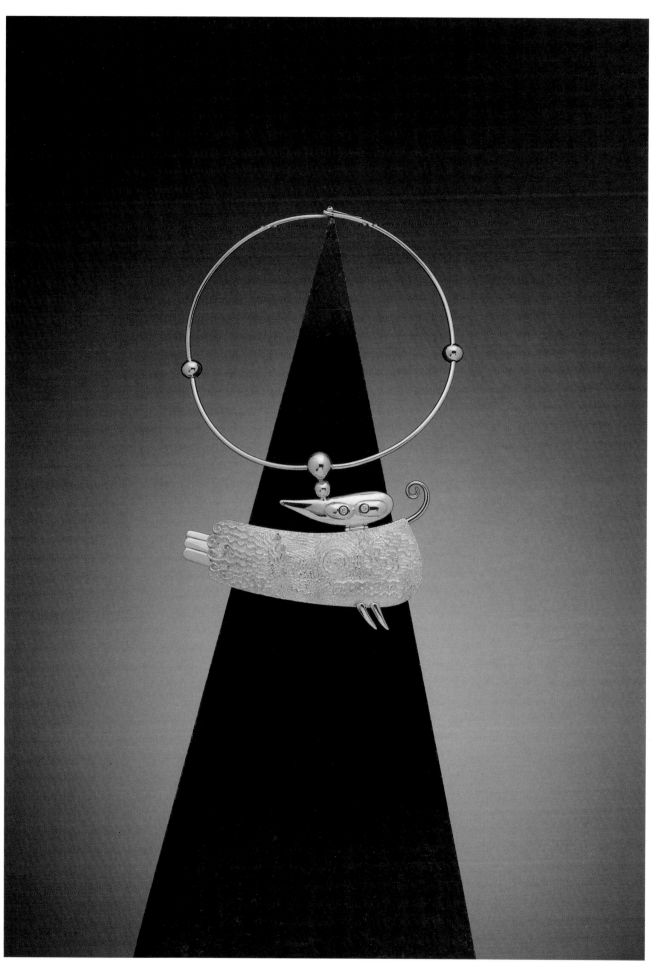

"Zoomorph n.6" gold necklace by Alberto Giorgi.

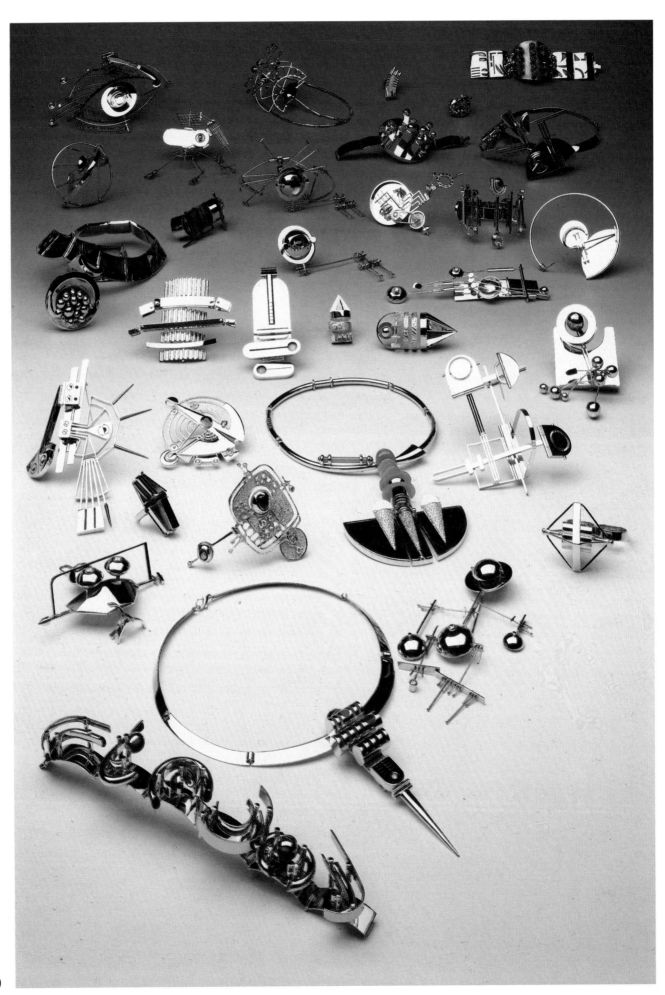

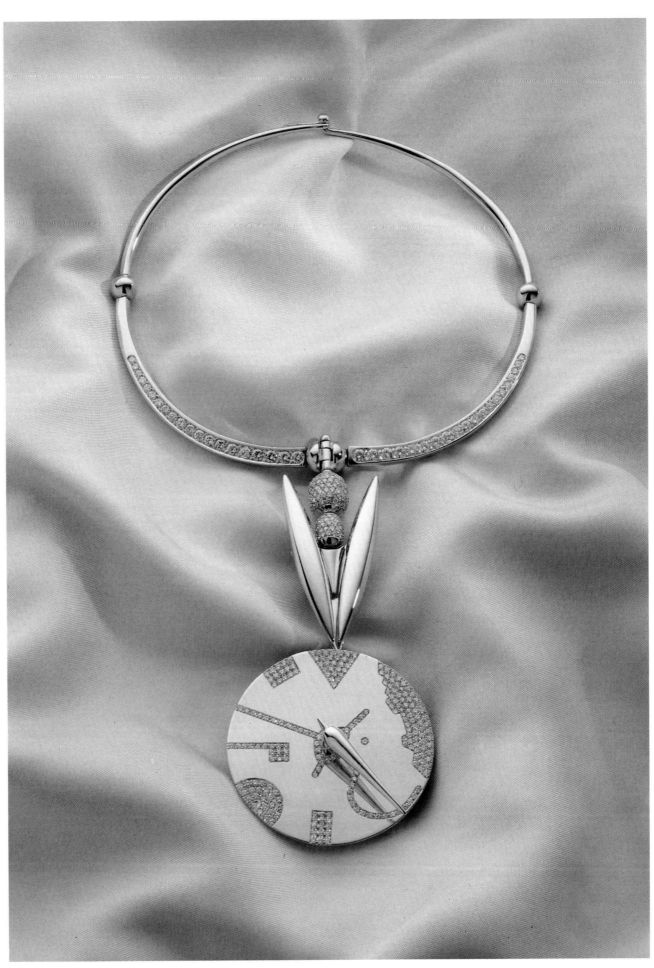

"L'Oiseau Philosophe", necklace of gold and diamonds by Alberto Giorgi.

MIRIAM MAMBER

"*T*he sense of eroticism is second nature to the human body but it can also be expressed in the creation of a jewel.

When I incorporate two opposite poles in a single piece, for example sand-blasted gold and the sparkle of diamonds. I suggest the magical, mysterious aspect of creation itself. When I create a ring, the juxtaposition of different materials allows me to transmit a many-sided, lively, imaginative idea. An idea which is also profoundly linked to the nobility of the precious materials."

Yellow gold "Erotic Ring" with movable central piece worked by Miriam Mamber.

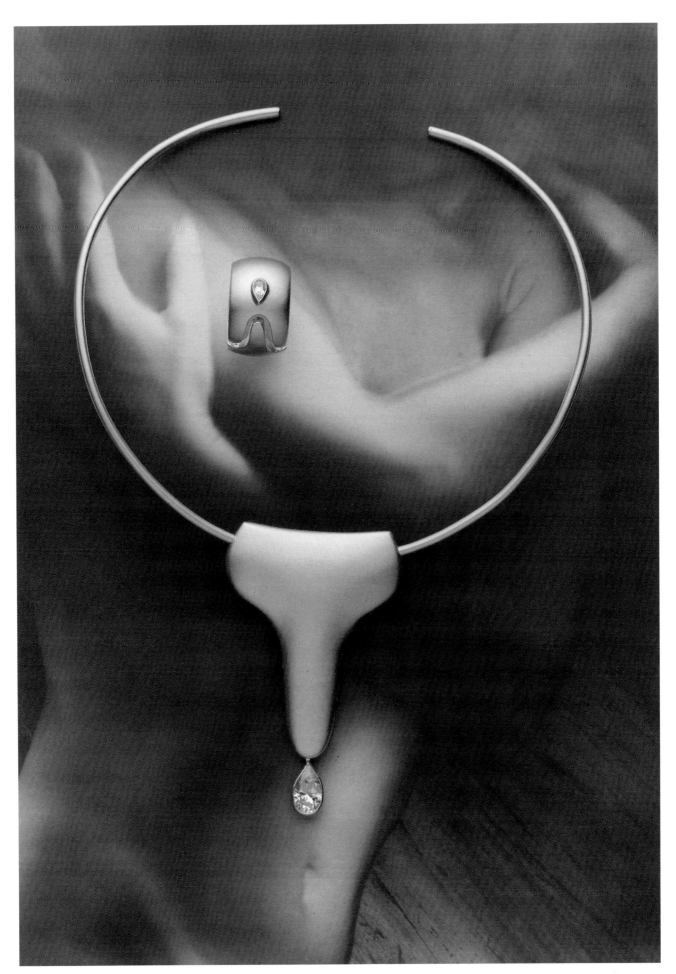

"Drop of Life", yellow gold necklace and ring with diamonds.

124 *Jacques Michel, creator of jewellery, painter and sculptor in Biévène, Belgium.*

THE POETIC

In collaboration with Jacques Michel

His jewels tell of fables and legends, he is in fact often dubbed the "poet-jeweller". His training as a painter undoubtedly contributed greatly to his reaching levels of lyricism that are quite outstanding in such precious works. Dreams, visions, and reveries populate his imagination and his creations carry us into a heavenly, unreal

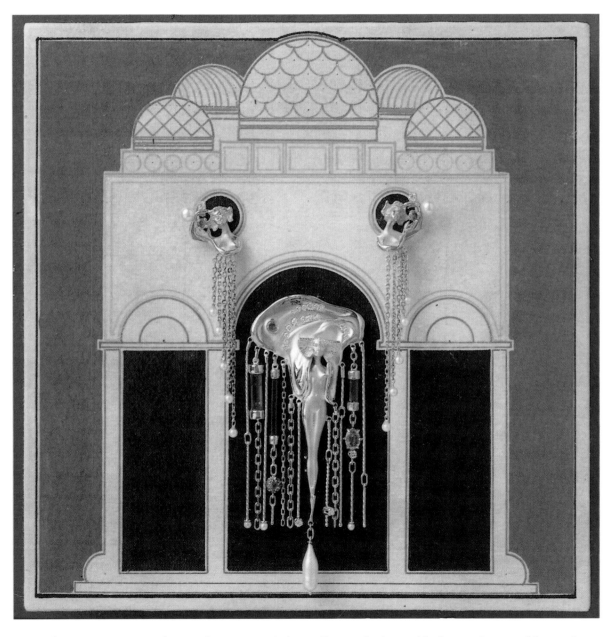

"The Byzantines", pendant and earrings styled in yellow and white gold, diamonds, emeralds, pearls and tourmalines. These pieces can be exhibited on top of a drawing inside a Plexiglas dome.

nebula whose origins lie in the erotic impulse.

"Eros, future messenger of love, is born of the union between Hermes, messenger of the gods, and Aphrodite, goddess of love. His mother sprang from the foam of the sea and his father was also protector of thieves. So together they bequeathed him the fluid mobility of the sea waters and an insidious, deceitful duplicity… This young god, already complex, loved Psyche, symbol of the soul – but their love was not serene."

This mythological tales plunges us into the subtle complexity of erotic symbolism, where the transposition of the vegetable and animal worlds merge and streak of humour are not uncommon.

Eroticism is the mainspring that sets our poetic dreams in motion. This is what distinguishes it from pornography, where there is no poetry, whatever our role (actor or spectator) may be.

In different times and places, according to cultures and latitudes, eroticism and poetry – in life and art – have taken on different guises. Limiting ourselves to the West, the road that runs from the point of a shoe glimpsed beneath the hem of a 17th century gown and the gesture of the 19th century lady removing her hat pins is long. However, each image, in its own time and way, had strong erotic connotations.

Today, at the dawn of the third millennium, culture and fantasies are different. Eroticism is therefore different too, since it is the direct result of a specific form of education. If sensuality and sexuality contain part of eroticism, the opposite is not necessarily true.

Eroticism is a way of alluding, but the allusion is not necessarily precise. It is the unfolding of more or less poetic or a sensual fantasy dream-like, but we do not know where it will end.

Is the eroticism of Salome at its greatest intensity at the beginning of the dance, when all her veils are still in place or at the end,

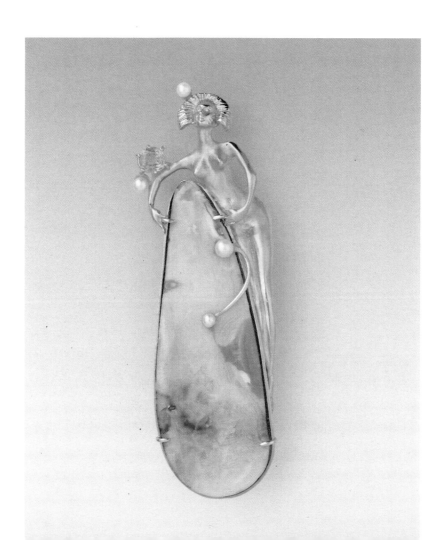

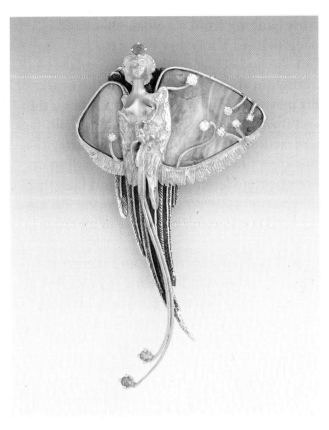

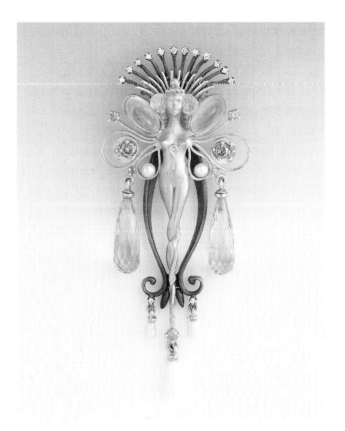

"Oiselle",
pendant-brooch in gold, silver, opals, diamonds and
emeralds.

"Tatiana",
pendant in gold, silver, blue, white and yellow
diamonds, aquamarines, blue topaz and pearls.

"Crystal",
pendant in gold, silver, rock crystal, mother-of-pearl,
emeralds, pearls and diamonds.

"Nanaméthyste",
pendant in grey gold, opals, amethysts, pearls, emeralds,
diamonds and lapis lazuli.

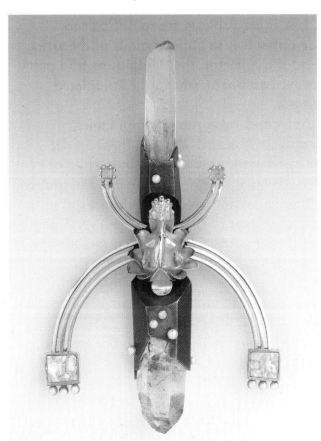

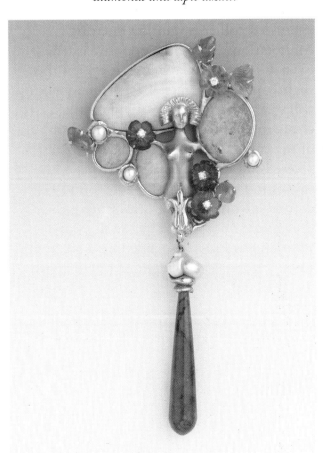

when the last silken cloak has slipped to the ground, revealing her body?

Art in all its forms, in its role as a testimonial and messenger of beauty, dreams and poetry, has often turned to the dreams of Eros, bearer of messages. No list can every totally convey how much painting, sculpture, literature, music and dance have expressed of this hrough the centuries. What then can we say of the everyday arts of clothing and hairdos, perfume, makeup and accessories… including jewellery?

Every jewel is a great vehicle of symbols of all kinds and every jewel has (or should have) a particle of poetry inside it (and there are many different kinds). It should also have, in a more or less prominent, well-defined form, the flash of Aphrodite's son simile.

The simple play of straight and curved lines, the mixture of soft and violent colours, the contrast between the heat and freezing cold of metals, the veiled opalescence of certain materials, flashes and sparks can by themselves quicken infinite images. The god hides, he leads us astray, covering his tracks. The god mocks us.

Do not ever believe, for example, that the most sensational, most formal diamond-encrusted collier is wanting in erotic connotations. Quite the opposite is true. Even as it lies inside its case, it evokes the slightly panting breast of the woman who will wear it. Artists and artisans worked to create much precious splendour by thinking of the colour and the warmth of skin.

There is no need to recall the erotic suggestion of a golden serpent wound around a woman's nude arm. And our dreams are not sparked by the sight of a simple silver cross suspended on a black silk ribbon, but at the thought of where it will lay. It is there that the spirits of our fantasy wander.

How many arrows, and how strong, can fly from the bow of Eros at the image of a country maiden with the simple wooden cross hanging from a golden chain and dangling just above her breasts?

But the god is just as able to insinuate himself in the object, making it the bearer of his messages. The jewel then becomes a sign and flowers and birds, faces, hands, hair, false abstractions and bright reflections carry the rustling of heavenly wings. The rustling can even be transferred to reptiles and fairs, the inhabitants of rivers and courtyards. All are exposed at the blink of an eye of a young god.

Eros plays with the virtues and defects of Hermes and Aphrodite. Eros seduces Psyche and troubles our souls. The artist believes the Muse and fails to see the laughing, mocking boy behind her. His Muse – calm, tender and gracious – is named poetry. But a young impertinent laugh awakens me and behind the pure curve of a shoulder I see the point of an arrow. Eros is here and he is mocking us, you, me!

"If eroticism in its purest form tends towards aesthetic emotion, it also often runs the risk of falling into licentiousness…" (Grand Larousse Encyclopédique-1960).

"Few other subjects are so difficult to describe. It is the unconscious of the artist, and the collector, that will put or find parts of its own phantasms in the completed object.

"As a child I was nurtured on fables populated by bird-women, flower girls, winged nymphs, chimaera butterflies or dragon flies, undines, mermaids and queens glittering with jewels. My adult inspiration contains part of that enchanted, sparkling world. It is certainly true that much of my pleasure in creating jewels, particularly subjects with erotic tinges comes out of those stories read so long ago.

"The magic of precious stones and metal has led me to probe the world of dreams and sorcery in my work."

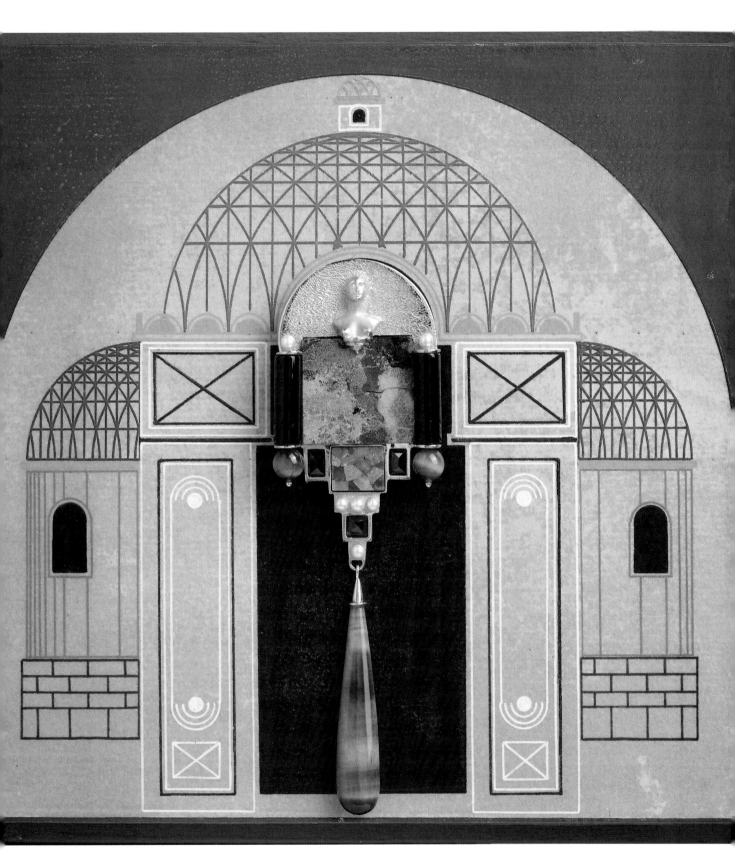

"Great Door", again on top of a drawing inside a Plexiglas dome, this pendant is made of gold, black agate, azurite, pearls, garnets, opals and tiger's eye.

GABRIELE WEINMANN+WIGBERT STAPFF

*W*igbert is the stone-cutter and Gabriele works the metals in these glorious creations, and it is truly difficult to find a duo more capable of producing such fine work. Symbolism, lyricism and poetry float out of jewels that seem to breathe with their wearer. As far as the brooch "Ikarus" is concerned, the movement of these precious feathers is not only a description of the curious bird that alights on the angel's breast. It is also an appeal to love and adore it. Like the star of the Three Wise Men, the polychromatic banners attract the eye and then guide the hand towards a breast that lets itself be caressed under the light fabric where the jewel rests. And the jewel itself moves with every caress, sensual, to the trembling of the wings of the bird of happiness. Only these verses by Charles Baudelaire can fittingly describe this jewellery of dreams.

LES PLAINTES D'UN ICARE

Les amants des prostituées
Sont heureux, dispos et repus;
Quant à moi, mes bras sont rompus
Pour avoir étreint des nuées.

C'est grâce aux astres nonpareils,
Qui tout au fond du ciel flamboient,
Que mes yeux consumés ne voient
Que des souvenirs de soleils.

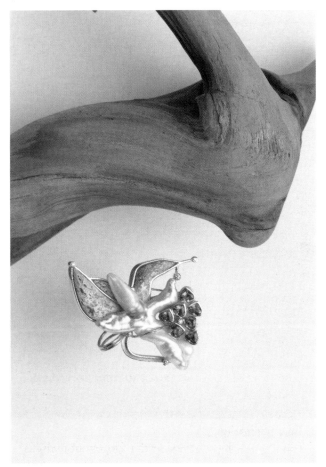

Gold brooch with diamonds, tourmaline, agate and biwa pearls by Wigbert Stapff.

Pendant in gold with fire opal, blue diamond, diamond and biwa pearls by Wigbert Stapff.

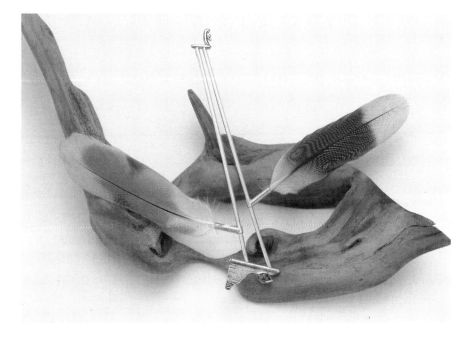

"Ikarus", brooch based on Chinese character for "flying" in silver, gold, tourmaline, and parrot feathers by Gabriele Weinmann.

En vain j'ai voulu de l'espace
Trouver la fin et le milieu;
Sous je ne sais quel œil de feu
Je sens mon aile qui se casse;

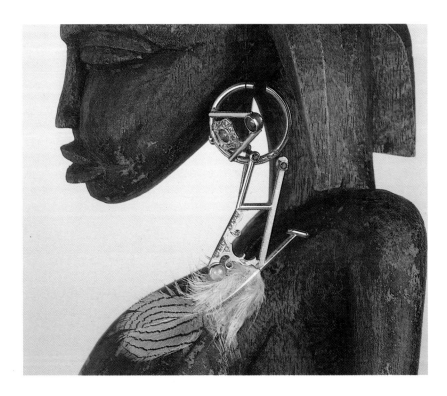

Gold earring, with blue and white diamonds, aquamarine, tourmaline, emerald, ruby, sapphire, chrysoberyl and a peacock feather from Isola Bella, Lago Maggiore. One-of-a-kind piece by Gabriele Weinmann.

Et brûlé par l'amour du beau,
Je n'aurai pas l'honneur sublime
De donner mon nom à l'abîme
Qui me servira de tombeau.

Charles Baudelaire,
Les Fleurs du Mal

THE LAMENTATIONS OF AN ICARUS

The lovers of prostitutes / are happy, robust and broken / and as for me, my arms are broken / from having embraced only clouds.
And it is thanks to the incomparable asters / that name in the depths of the sky, / that my worn-out eyes can see / nothing but memories.
In vain I wanted to find / the end of space and the centre; / under I know not which eye of fire / I feel that my wing is broken;
and burnt from love of beauty, / I shall not have the sublime honour / of giving my name to the abyss / that will become my tomb.

131

SIMONNE MUYLAERT-HOFMAN

*H*er sensitivity turns her jewels into vibrant, throbbing works of art, poetry expressed with flowers, dragon-flies and shells. Their highly symbolic eroticism is discretely expressed with great purity. A tiger's tooth or the opening of a sculpted horn provide glimpses of a sensuality yet to be discovered. When worn, Simonne Muylaert-Hofman's one-of-a-kind pieces with their special colours and forms pull the eye towards a woman's erogenous zones.

At any movement they throw an inviting, discrete message that no partner can ignore. One of Simonne Muylaert-Hofman's great talents is her extraordinary ability to create jewels that reflect the personality of the person who will wear them. Better yet, we might say that she lets herself be guided by the wearer's moods. I have often thought that this great artist manages to "see" the final destiny of each of her works. Meeting her, and having her create a unique, personalised jewel is, in my opinion, one of the great privileges of our age.

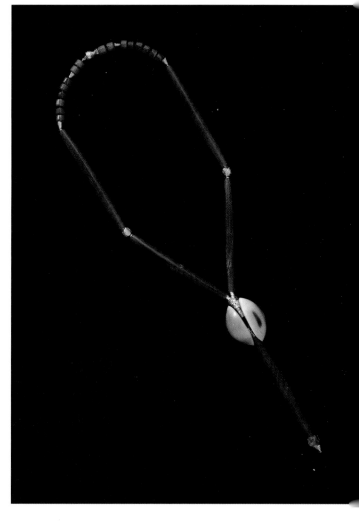

Necklace with tiger's tooth, horn, jasper and amber. One-of-a-kind piece by Simonne Muylaert-Hofman.

Necklace in gold, horn, jasper and amber. One-fo-a-kind piece by Simonne Muylaert-Hofman.

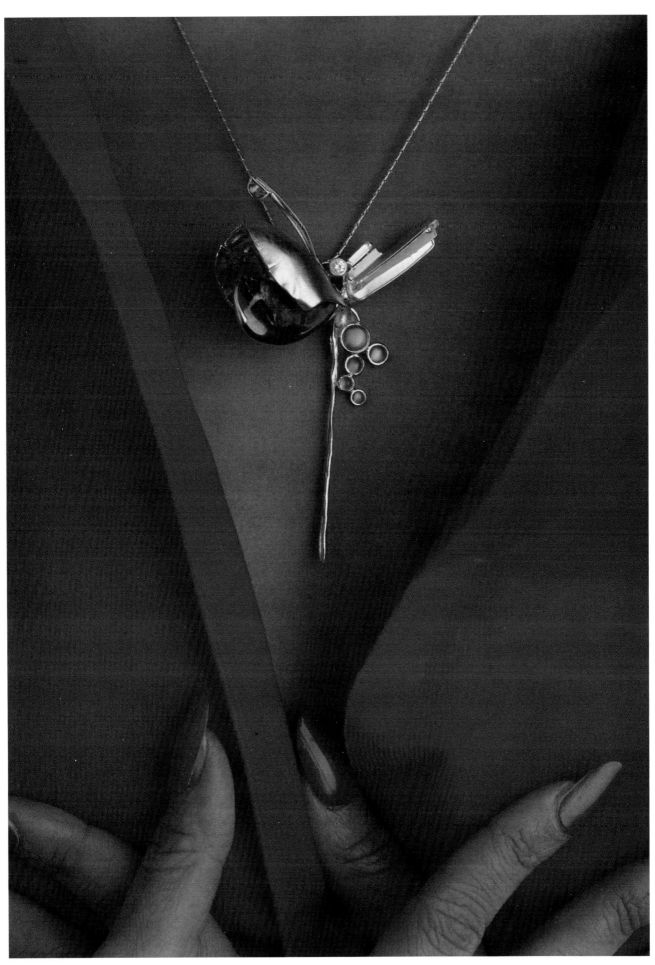

Gold pendant, with opal, moonstone and diamonds. One-of-a-kind piece. 133

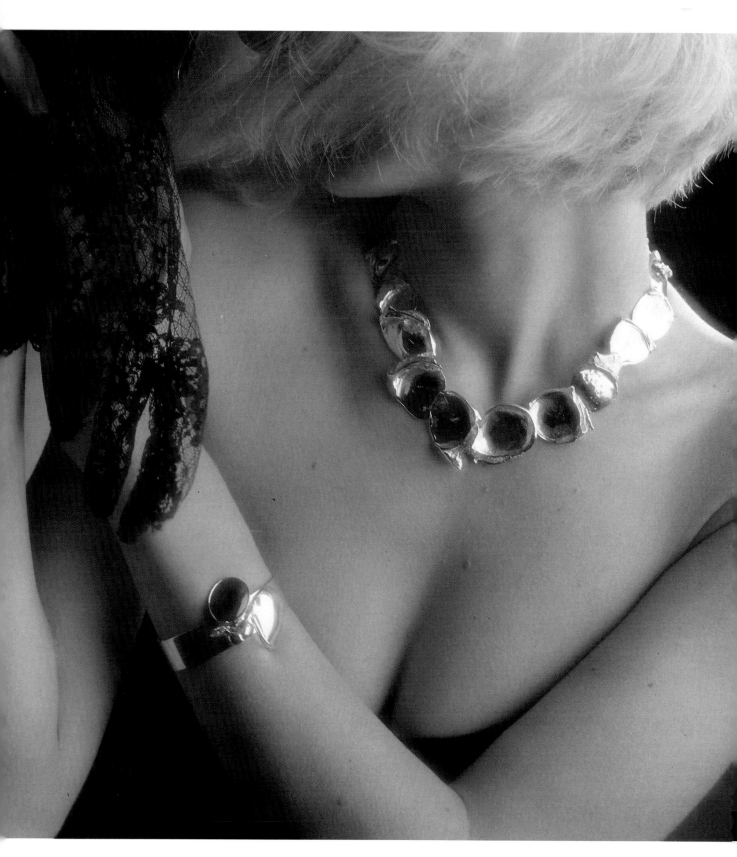

Necklace in yellow gold and bracelet in gold, labradorite and brilliants. One-of-a-kind pieces.

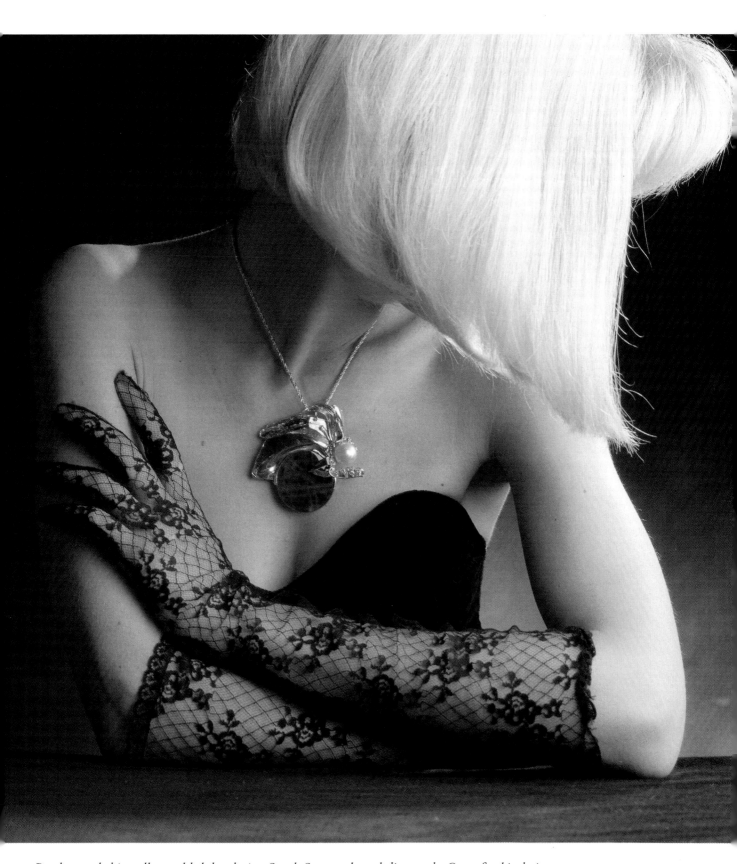

Pendant styled in yellow gold, labradorite, South Sea pearls and diamonds. One-of-a-kind piece.

SIMONE VERA BATH

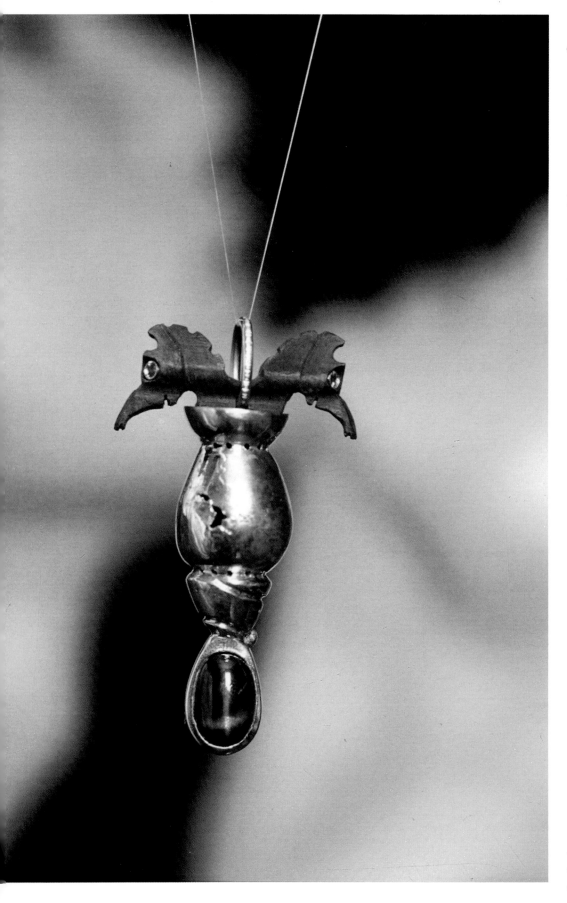

*S*imone Vera
Bath is inspired
essentially by love –
this symbolic love
that has
transformed a
simple piece of
jewellery into a
work of art, thanks
first to its form and
then to its use. Born
in Berlin, Simone
Vera Bath works in
Rome and Florence
but her work travels
throughout Europe,
particularly in Italy.

*"Symbiosis", two bodies,
prisoners and united in
fusion: their senses are
free.*

"The Cage of Souls": the force of their passion finally freed them, energy gives them life.

IMTHIAS KALEEL

*T*his creator from Sri-Lanka presents his
"Birds in Love", a brooch in yellow and white
gold with blue and white sapphires.
Enchanting lines and forms sending
sensations of tenderness and warmth.

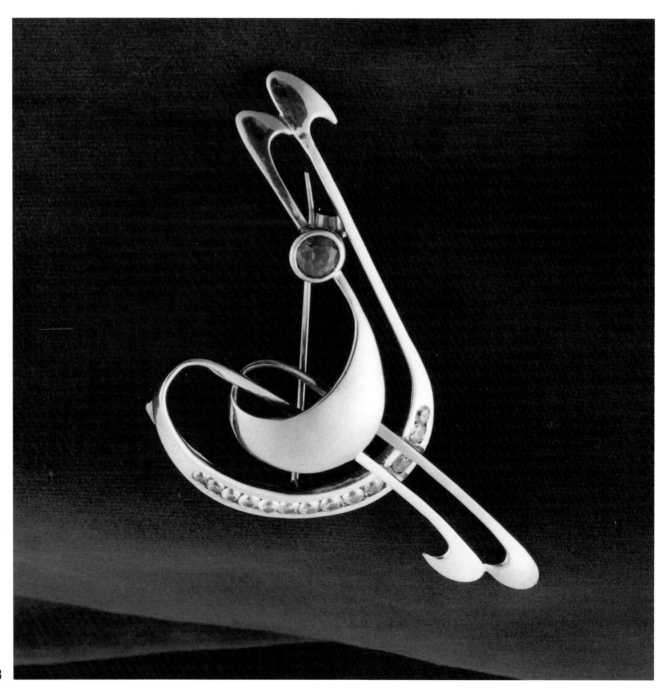

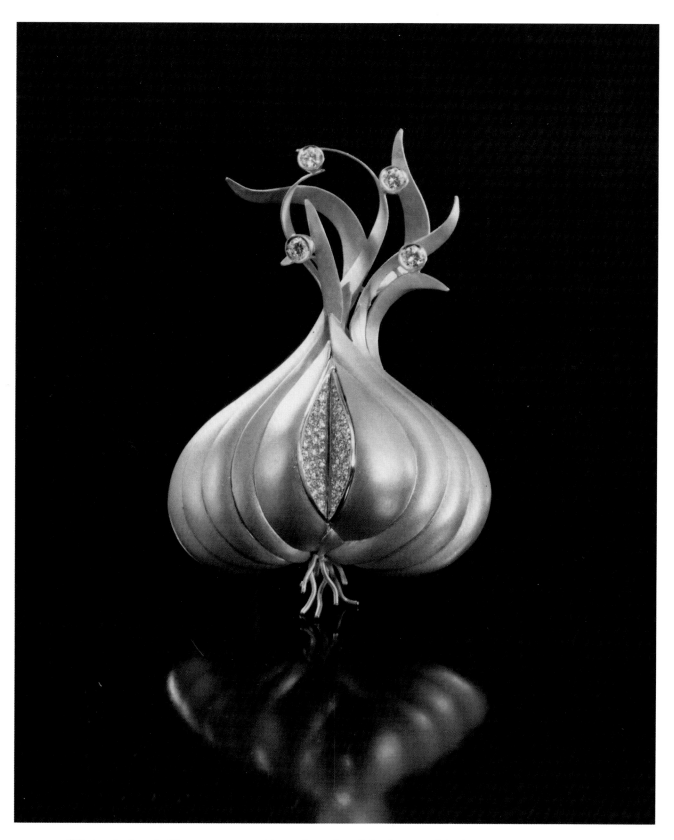

*"Onion in Love". Humorous composition, where the subtle elegance of the forms highlights the precious
interior. Jewel-sculpture in yellow gold and diamonds.
One-of-a-kind piece by Flavio Ricci.*

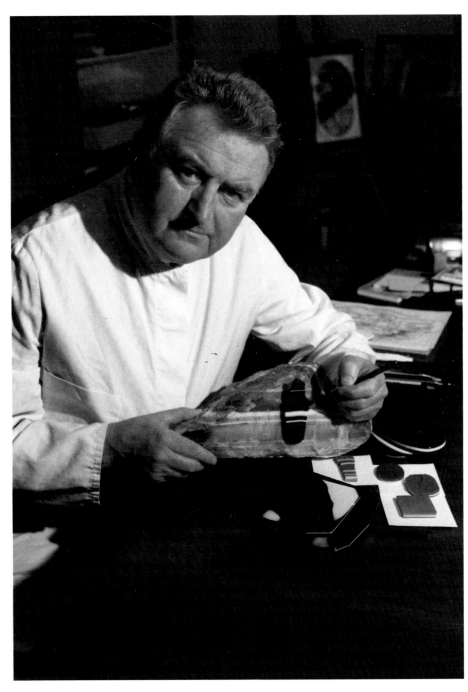

Erwin Pauly, stone-cutter, designer and sculptor on precious stones in Idar-Oberstein, Germany.

CHAPTER VI

SENSUAL GEMSTONES

In collaboration with Erwin Pauly

*T*t is no easy task to find the traces of eroticism in fine gemstones. However, in spite of this there are artists who can transmit a message through these cold, noble stones. Thanks to their presence their work carries whispers of sensations, symbols and sentiments. Erwin Pauly, heir of a long tradition, talks about his work and tells us his story:

"The miraculous earth we live on gives forth every possible variation of precious stones. For over 6,000 years it has given artists new challenges for their creativity.

"What drives an artist to work on a precious stone, to see something special in it, to try to trace the face or body of a beautiful woman as the Creator of all things wanted them to be?

Letting himself be guided by a gemstone's particular cut, hardness and colour, the artist demands that it let itself be transformed into something special, into an object that fascinates and moves him. Throughout the centuries, the use of various often quite simple techniques has led to the creation of art objects of new and original forms and cuts, from the cylindrical seals of the region of the two rivers in Iraq – the ancient metropolis of Ur and the art lover King Gilgamesh, – to the cameos from the court of Alexander the Great.

"The Renaissance was the beginning of a new era, dominated by the power of religion as well as the immense prestige of the Medicis. All of us today are their heirs. We have a great debt to gratitude towards the Medicis and their great creators of miniatures for the magnificent works in crystal and precious stones they have left behind. Back then, cameos, engravings and sculptures followed the rules of classical tradition. In their round, oval and cabochon cuts, faceted gemstones gave artisans the most suitable formal task to create work on the stone's back surface. At the same time, they infused their love and desire for another in the object.

"The great poet Goethe expressed his taste for cameos in many of his works, a fondness that arose during his travels in Italy. Today we know that what attracted him most was the beauty of the engraving, particularly the expression, charm or grace of a female body that loves and is humbled for the sake of love.

"My grandfather learned how to do stone-cutting, what the Greeks called glyptic art. Both my granparents and my father loved to express themselves in the classic cuts. So it was not until 1949, that I was finally able to follow my own leanings in the art of miniatures on precious stones. It was essential that I master the classical style and its difficult techniques. After my first success, however, it was clear that the century had to end, differently from the way it had started. For me this meant seeking new forms, experimenting the field of abstract, both in external forms and in tonality – tones to be adapted to a previously chosen topic, tones that could give rise to special chromatic effects.

"When I was still training, and being influenced by different masters, I gradually started modifying the expressive possibilities I knew. The result was a new type of engraving: I recognised the abstraction of stratified stones, the multiplicity of the nuances. I suddenly understood that there were new possibilities for stone-cutting, which would require making sacrifices.

"So what is the new approach different from the classical style were its possible to catch new nuances? Let's take a musical motif as an example.

"By choosing the cameo technique I wanted to attempt a concrete visualisation of opera. For the 'Queen of the Night', for example, I chose a three-layer Brazilian agate that allowed me to insert contrast and atmosphere in the material – the night and its darkness. Black knights in the first layer, a delicate blue-black for the queen's face and a final black layer as the mystical backdrop. This graduation also represents the nocturnal migration of the stars which I depicted as a falling star going from bottom to top using a black diamond. Other diamonds on the moon's crescent are additional sparkling points to illustrate the opera theme of *The Magic Flute*.

"'Carmen' is an eternal play of love, passion and betrayal. I portrayed it with a three-layer Brazilian stone with a yellow sapphire for the day, a blue sapphire for the night and diamonds set in white and yellow gold to capture attention.

"'Tristan and Isolde' in blue-black Brazilian stone depicts the well-known scene where the lovers drink from the cup under the overhanging branches of a tree. An essentially abstract form portrays the unfortunate lovers.

"The golden crown with its undulating forms and the diamonds symbolising the Northern Lights are both fitting additions to the scene. The two sapphires reflect the colour of the water where Tristan's ship sails to reach Isolde; the emeralds pick up the colour of the leaves and the centre rubies and diamond are symbols of love.

"For the cameo 'Apollo and Daphne', I chose a red layer to depict Apollo's flames of love for the nymph.
"The characters' position denotes an enigma that no one has ever been able to explain. All that remains is fascination with a remarkable event.

"For the 'Poseidon in Love', cameo, I decided to use form and engraving in this stone to depict an underwater scene. The dolphins are initially the main motif where the figures of the mermaid and the god of the sea in love with her are of prime importance. The agate's natural inclusions strongly influenced the mermaid's shape who changes into a dolphin to escape Poseidon. The god is in turn bothered and distracted by another dolphin. The two young dolphins below are obviously bursting with joy.

"I decided to incorporate the natural form of the stone in my work recreating the myth of the 'Udine' in beryl. After making my first sketches, I worked on both the front and the back to perfect, the Udine's perfect body.

"On both sides the uncut crystal represents water, the element that the nymph is about to abandon. She then remembers that water is the element to which she owes her life and that her love for men on the earth is a taboo.

"So my ideas have left their mark on the end of this century. For the new times to come, minerals will remain a source of joy and artistic inspiration.

"My children have taken the same road. Hans Ulrich has been in charge of the incisions of gemstones at Idar-Oberstein for

19 years. He applies his own creative concepts and is also a famous sculptor. Andreas discovered his love for precious stones after he finished studying economics. After specialised training he has turned his efforts to the creation of new forms in cameos. Like his oldest brother, Gerhart, the youngest Pauly, started his apprenticeship at his father's side. He then took courses in gemstones and jewellery design at Idar-Oberstein, Rheinland-Pfalz. His diploma design piece was dedicated to terrestrial essence and its representation in precious stones."

"CARMEN"

A symbolic figure from the opera by George Bizet is represented using Brazilian agate with black-white-black layers set in 18 carat yellow and white gold. The raised dome-shaped yellow sapphire, represents the day, the blue sapphire and diamonds the night. Carmen: a tragic, well-loved figure, killed by Don José in a burst of passion and jealousy.

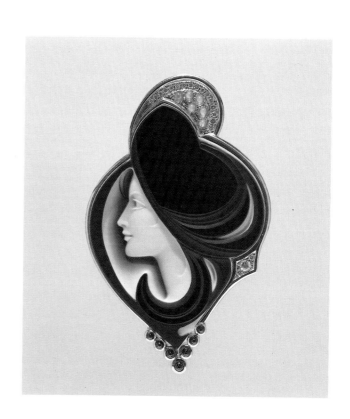

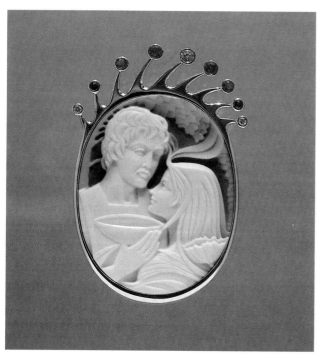

"TRISTAN AND ISOLDE"

The characters of Richard Wagner's opera are reunited, overcoming the great distances that initially separated them. From the outside to the inside, the setting contains a diamond for the light, two sapphires for the colour of the water Tristan crosses to reach Isolde, two emeralds symbolising the leaves of the branches overhanging the lovers as they confessed their love and drink from the large cup; two rubies symbolising a love that not even death can destroy. The cameo is cut in a layered Brazilian agate.

"QUEEN OF THE NIGHT"

From *The Magic Flute*, by Wolfgang Amadeus Mozart. The figure of the Queen is engraved in a three-layer Brazilian agate. Her hair on the upper black layer is abstract, appropriate to this nocturnal apparition. The setting, in 18 carat yellow and white gold underlines the tenacity of the queen who uses her feminine arms love and hate. The shining band that rises from the bottom represents the revolution of the stars. An uncut diamond, over 2 carats, symbolises the night while a falling star, detaching itself from a group, of stars, rapidly disappears. This involves a group of diamonds representing an abstract oval. The crescent of the moon in 18 carat gold and the diamonds are of primary importance in defining the scene.

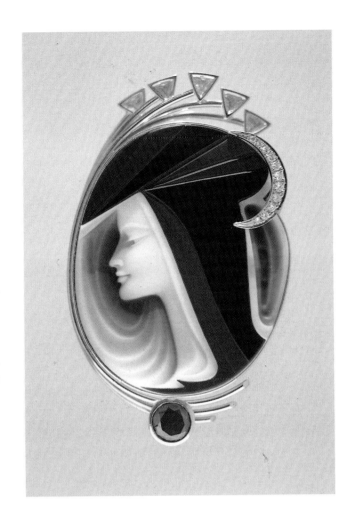

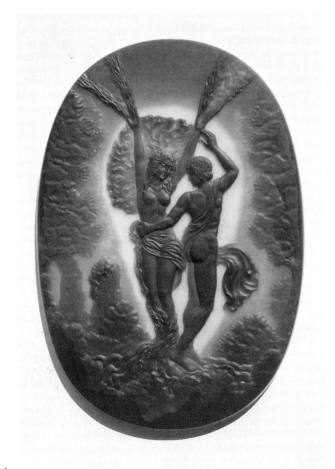

"APOLLO AND DAPHNE"

Apollo follows the nymph who begs him not to touch her. The lovers' ardour has no limits and the fatal meeting is highly dramatic. Under the god's passionate caresses, Dalphne stiffens and her hands and feet become motionless as they emit branches and roots. Apollo is deeply disturbed by the unexpected turn his desire for the nymph has taken.

"Through '92, I used stratified Brazilian stones to represents the four seasons. Being colourful and symbolic, even the most neutral stone allows a wide range of freedom of thought and interpretation. The green of spring is not smothered by the intense red of summer, just as autumn's brown leads one to realise that the forces of nature will soon depart. Harvest time is over and the winter will bring snow and ice. The black-white-blueness of the engraving stimulates the observers' questions. Or on the contrary allows them to liberate themselves to free flow of their thoughts."

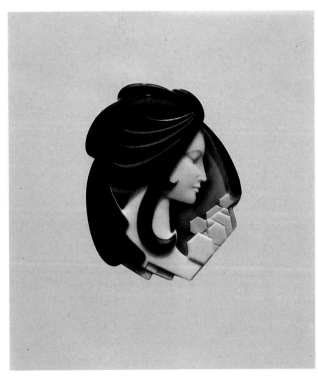

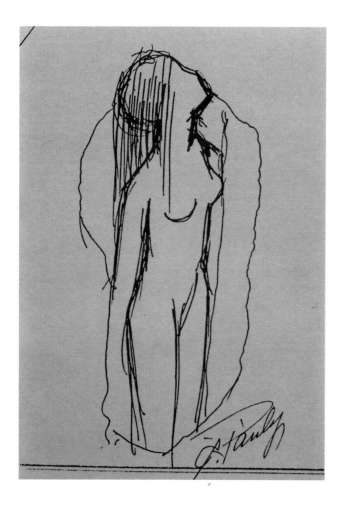
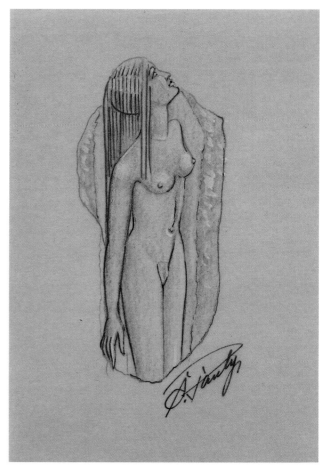
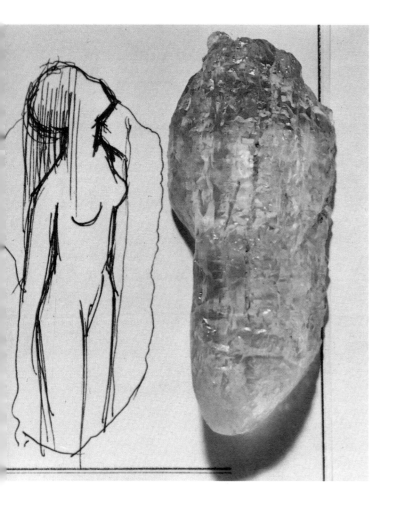
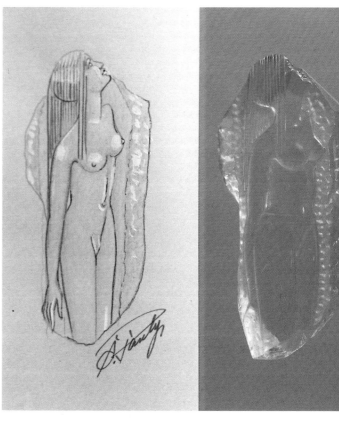

Birth of a sensual stone: "Undine" beryl sculpted by Erwin Pauly.

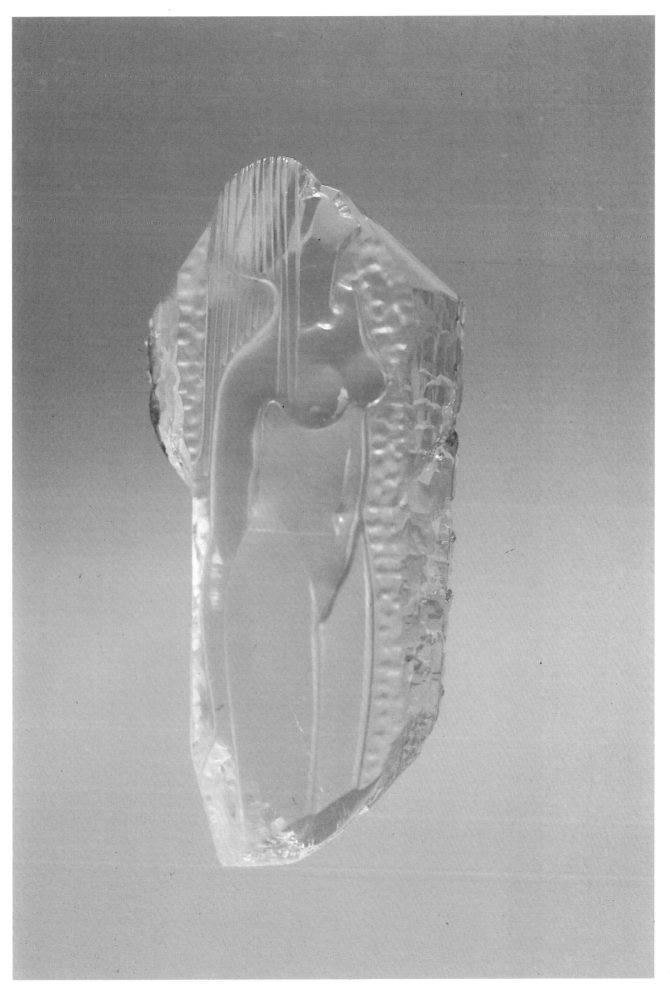

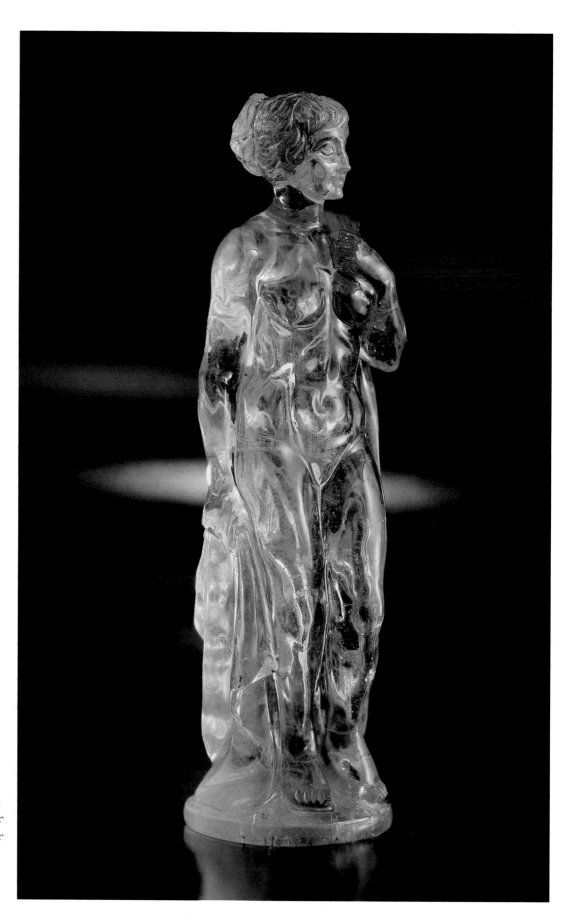

Herbert Klein
Minisculpture
made of
aquamarine of
rare beauty;
incomparably
148 *precious (9 cm).*

HAROLD VAN PELT

*V*enus/Aphrodite: this is
Harold Van Pelt's muse.
Only a truly great artist can
begin with a form and
manage to bring even the
tiniest detail of his dreams
to life in such minute
dimension.
The beauty, purity,
sensuality of lines, with
warmth of the colours are
all hymns to love.

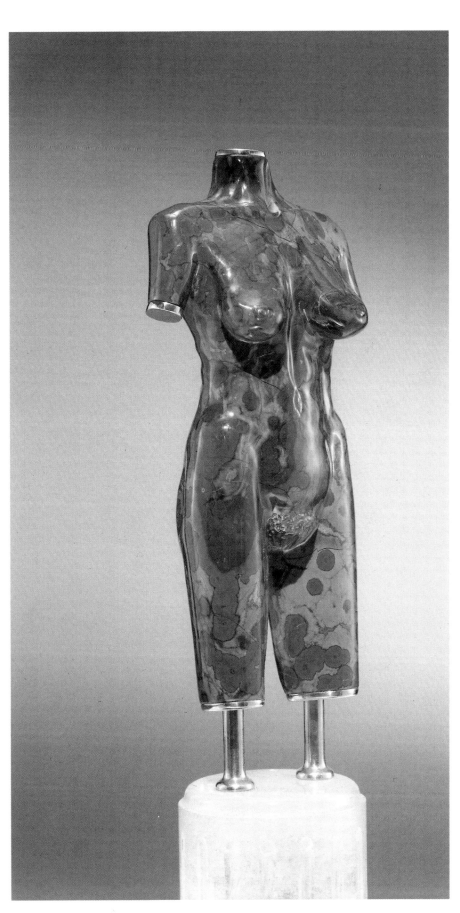

*Female bust sculpted
in jasper by Harold
Van Pelt, Los Angeles
(19 cm).*

PHILIPP BECKER

An artist's phantoms
finally unveiled. Philipp Becker,
authentic magician of the art of
stone-cutting, deftly transforms
a mineral's coldness into a
volcano of desire.

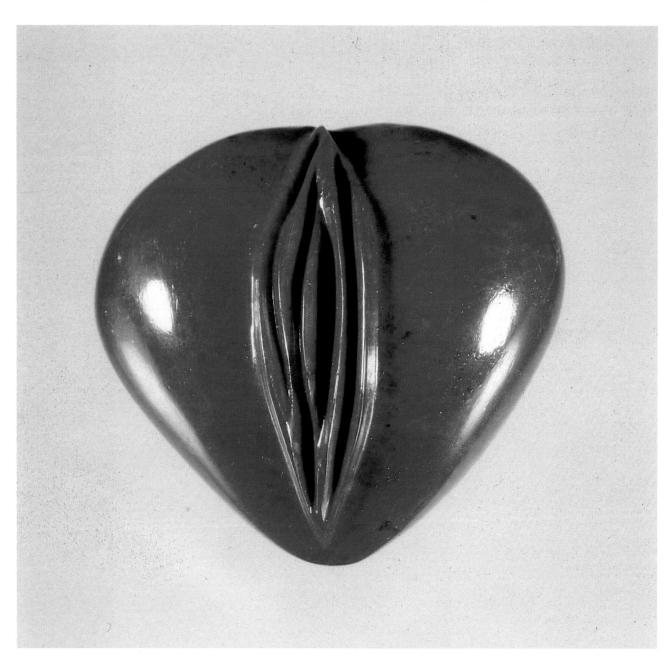

"Claudia", a heart of lapis lazuli willing to say - or do - anything at all, an Erotisches Objekt that never leaves you

cold.

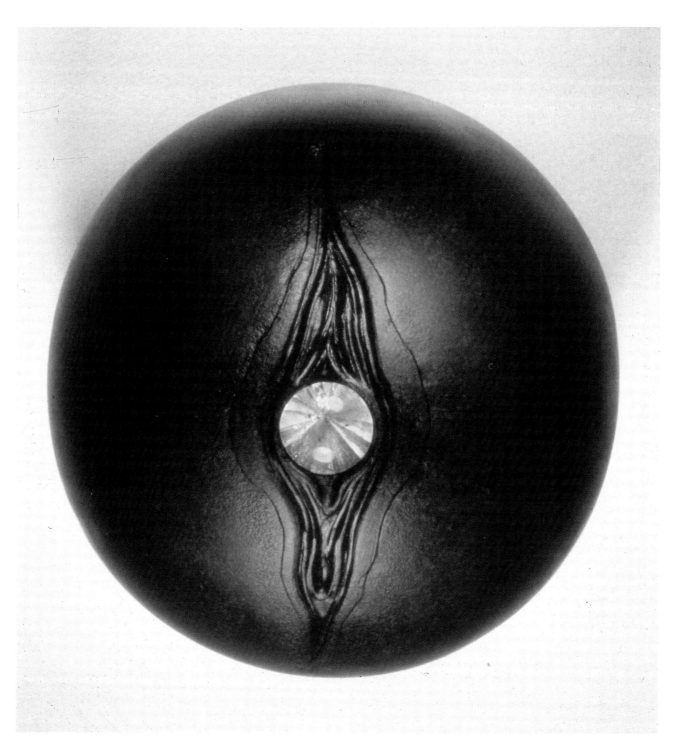

"The Most Precious Desire", *another erotic object created with great skill by Philipp Becker's team. The central stone is a magnify-cut aquamarine.*

152 *Photo shot in 1939 in North Africa. Private collection of the family of Gianni Vetrano, Rome.*

OTHER FORMS OF EROTICISM

MYTHOLOGICAL LOVE

"*B*achanalia" These unusual, very special creations are meant to recreate one of the most famous pagan festivals, the Bachanalia.

Experts in mythology agree that these celebrations, also known as the Dionysia – from the name of the god Dionysus/Bacchus – were taken to Greece from their native Egypt by Melampus, son of Amythaon. According to Herodotus, it was he who introduced the cult of the phallus to the Greeks, along with that of Bacchus. The Athenians celebrated these festivals with great pomp and the Romans did not hesistate to introduce the custom to Rome and all the cities of the empire.

The main ceremonies consisted of processions where young men carried huge urns full of wine, crowned with vine-leaves. Young women followed bearing chests full of fruit and flowers, then men carrying lamps and torches, flute and cymbals players and, finally, groups of men and women masquerading as satyrs, fauns, Silenus, nymphs and bacchantes. Crowned with laurel leaves and animated by wine vapour, their gowns draped with beguiling art, uncovering what should have been covered, the revellers sang the *phallica*, obscene songs in honour of Bacchus.

When they reached the site of the ceremony – a clearing in the midst of a silent wood in a deep valley surrounded by rocks – the possessed revellers pulled an image of Bacchus, which the Latins called the *arca ineffabilis* out of a chest, leaned it against a herma and offered it a pig in sacrifice.

Abundant wine and fruit were distributed and soon the libations, loud cries, riotous joy and promiscuity aroused the senses and a general orgy resulted.

Despite the many participants everyone acted as if he or she were alone in the world and the most extreme forms of licentiousness had hundreds of people as spectator-actors.

The bas-relief on which this description is based depicts a typical Bacchanalia.

Old Silenus is in the centre, crowned with ivy, with a cup in one hand and the crown won from the other drinkers in the other. Two young fauns hold up his unsteady steps, keeping him from falling.

Behind him are a torch-bearer and a caephyr bearing flowers and fruit; to his left we see a woman playing cymbals, a young man carrying some instrument needed for the initiation rites, an indecent phallus-bearer tightening his belt and finally, a woman-satyr depositing staff and mouth-organ at the foot of the herma of Bacchus, recognisable from the horns and fanskin covering the bust.

At the top, Cupid can be glimpsed in one corner, undecided as to whether he should join in.

To the left of Silenus there is a tiny altar under a pine tree; a torch is the sign that the sacrifice is ready.

A woman reveller is resting on a bearskin and her position leaves little doubt as to the cause of her exhaustion.

In the back group, a satyr is coming out of his house, attracted by the noise and eager to join the orgy.

Finally at the far left, a woman masquerading as a satyr makes full use of the attributes of Priapus.

153

The entire scene takes place in a woods where oaks and a palm tree can be seen. The stone-cutters inspired by this mythological scene have created a masterpiece, reproducing the sites and figures of this parody in all its detail in very restricted space. (Private collection, Cellina Barth).

154

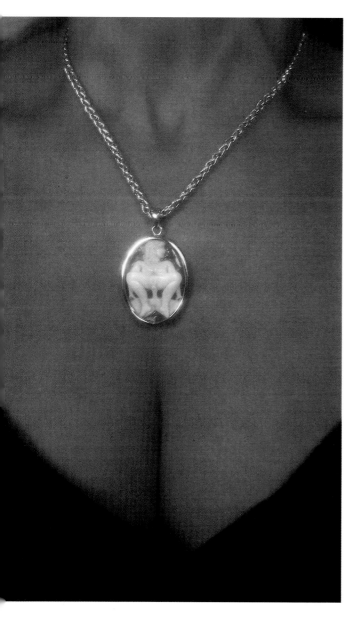

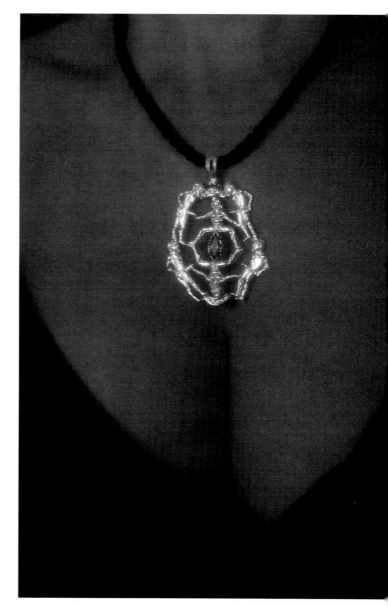

*Two original works
by Maestro
Marcello Pizzari.*

LINA FANOURAKIS

SENSUAL MOVEMENT

*T*his is certainly not one of the simplest expressive forms. The jewels created by Lina Fanourakis are a continuous evolution itself, a slow, elegant movement similar to alga floating on the water's whims.

Her "Dance of the Nymphs" illustrated here consists of a series of four brooches that can be worn together or separately. In either case, these jewels – which recall nymphs, fairies, mermaids or nude dancers shedding their veils – are permeated with a subtle sensuality.

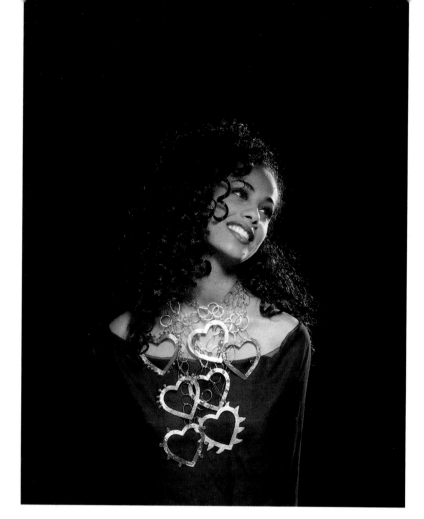

GEORG SPRENG

PRECIOUS, EROTIC AND... GIGANTIC

*T*here are no limits to a jewel's size as far as Georg Spreng is concerned. Some years ago, moved by the desire to build a bed for his son, Spreng felled a tree. And when the boy grew and the bed was too small, Spreng took it apart and made an extraordinary necklace with a magnificent heliodor in the middle.

"Shining Hearts" (*left*), a precious object in gold, platinum, rubies, sapphires, tourmalines and topaz that can be worn separately.

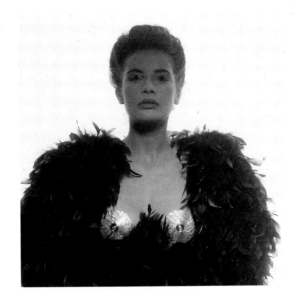

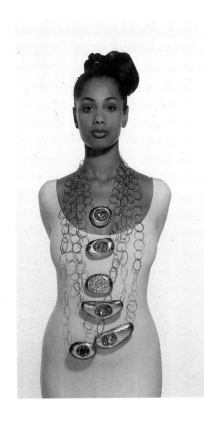

He has also created other pieces, such as the "Dance of the Pearls" (*right*), a diadem-necklace in gold, platinum and pearls or, as a bra, in gold, yellow diamonds and pink tourmaline. It can also be worn on the forehead.

"Roasted Potatoes", enormous pendants with pearls and gemstones. These pieces, patiently and skillfully chiselled for days on end, are extraordinarily sensual to the touch.

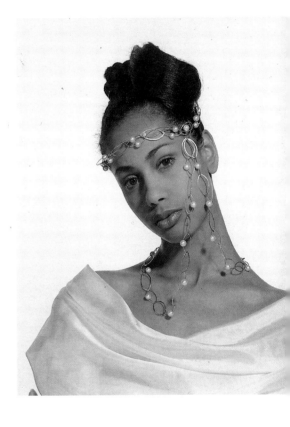

"The Wings of the Angel", a pectoral in yellow gold, platinum and a 156 carat kunzite. This object of obvious sensuality sets off the neck, shoulders and breasts of the woman wearing it. "In this creation, I endured the difficulty of uniting fire and water."

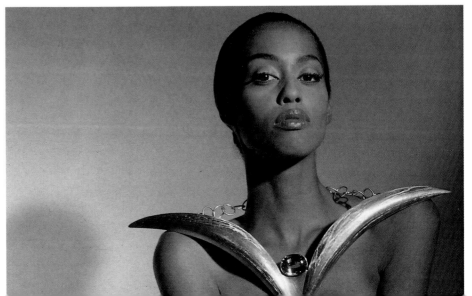

CORNELIA FRECHE

SENSUAL JEWEL-GOWNS

*C*ornelia Freche has created an extraordinary collection of gowns that could also be considered jewels. "Art is never an end unto itself. Quite the opposite. In my creations it is inseparable from the body in movement, where embellishment of a woman's energies enhances her natural erotic aura."

Having studied the creation of body and spatial jewellery, Cornelia Freche is working her way through discoveries without precedent: a return on the one hand to primitive ornaments and, on the other, a projection of what will be worn in the future. Only a few lines are needed to accentuate the eroticism that emanates from a naked body.

LOUISE HARRIET BORGEN

SENSUAL JEWEL-GOWNS

*J*ewellery chosen for clothes designed to wear as jewellery: that is a point the great creators often discuss. Fashion designers design false jewellery, jewellers market precious perfume. Louise Harriet Borgen, an Anglo-Norwegian whose family have been jewellers for four generations, has conceived a series of jewel-gowns. A skillful blend of precious metals and carefully selected fabrics is the basis for these original, provocative ornaments.

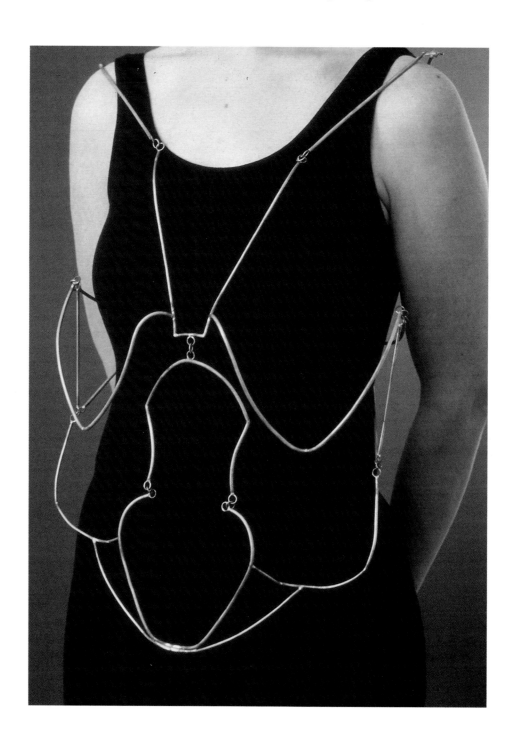

ORNA CAHANER

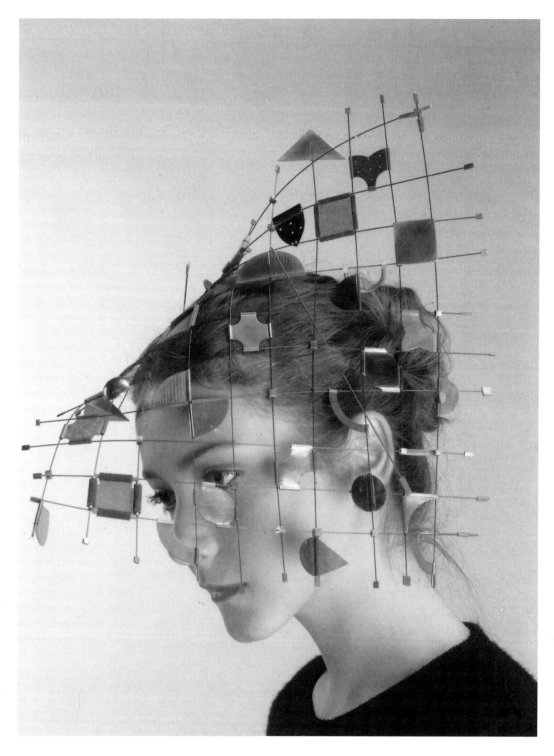

Hat or enormous jewel, this refined ornament gives us a glimpse of the discretely displayed colours, lines and emotions of a face.

SENSUAL JEWEL-GOWNS

The intimate relationship between a precious object and the human body is strongly accentuated by the colour and surface pattern of the metals used. Orna Cahaner has captured in the sensuality of the veil, the elements needed to create a hat in precious metal.

DANIEL VAN NUFFEL

EXCITING MECHANICS

*P*erfectionist by nature and lover of mechanical jewellery, Daniel Van Nuffel has managed to make a perfect reproduction of a "Harley Davidson Electra Glide". He speaks of it here with genuine enthusiasm.

"All I need is a few pages to describe by creation: my very soul lives in my work. Just the thought that I have managed to construct a miniature gold motorcycle and that this work will live forever, excites me immensely.

"Concentrate on your feelings when your legs touch the soft leather of the seat. I personally have the feeling that I am naked and find the mere smell of leather exciting. It is just like the garden of Eden. The chrome blinds my eyes, the hum of the engine sounds like a wild panther. I am sure that all men share the temptation – or at least the mental image – of having a relationship with this infernal machine."

SUNGMIN HONG

BIOLOGICAL EROS

"*L*ove is competition" is the
brilliant title of the piece created by this
highly talented Korean artist. Sungmin
Hong unveils the sublime moment of the
encounter between an egg and a sperm:
the magic instant when the two elements
compete before uniting, forming the
embryo of life.

Brooch of yellow gold, gilded mabé, fresh water pearls, diamonds and black agate.

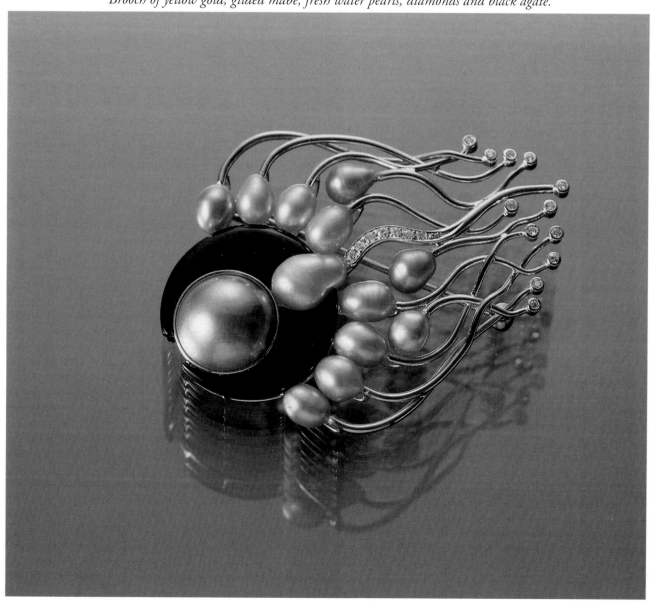

LENA ANTABI

MESSAGE ACCESSORIES

*O*ne of Lena Antabi's most intuitive creations is undoubtedly "Stringless", a very special piece of jewellery that initiates can well see is both discrete and racy.

Lena Antabi, one of Brazil's most important jewellery artists, has created a ring to help lovers communicate: worn with the smooth surface turned towards the palm of the hand, the jewel reveals that the person wearing it has been touched by Cupid's arrow; worn in the other direction it authorises every type of advance.

166

JULIANE ARNOLD

MESSAGE ACCESSORIES

*U*p until now, the most erotic parts of the human body were located below the belt. Juliane Arnold decided to move the boundaries of the forbidden, turning the belt itself into an erotic accessory. A glimpse of the buckle is enough to awaken dormant senses. No longer an accessory, the belt has become an erotic ornament, an invitation to pleasure.

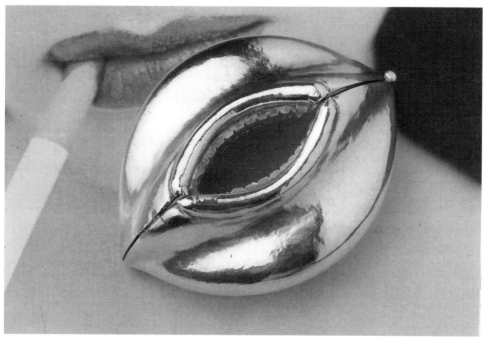

Silver hair pin and belt buckle.

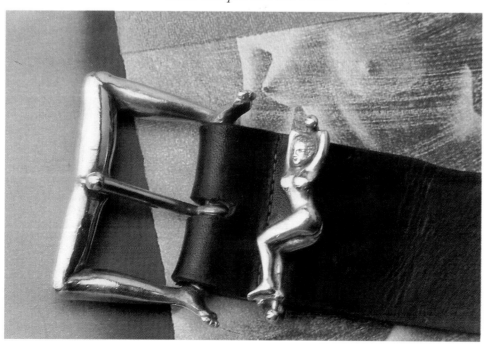

CLAUDE MAZLOUM

" *A* man of great modesty, Claude Mazloum is an artist of even greater talent. "The author of this magnificent collection had no desire to speak of himself and has entrusted me with this difficult task.

"I am sure that not even an entire volume would be enough to present the full range of his creations, ideas and his discretion, but essential activity towards the realization of many international masterpieces.

"This piece is only one tiny example: this condom-holder, rediscovered only recently in a drawer where it had been left lying since 1970. At the time it was considered a useless object but for Claude Mazloum today it is an elegant way of demonstrating his active participation in the fight against AIDS.

"This jewel-object is a revelation, illustrative of its creator's fore-sightedness and points to his commitment. He takes care in transforming each object into a collection piece, without depriving it of either its usefulness or its reason for being."

François Renac, composer and passionate art lover, honorary doctorate in musicology.

Unisex pendant or key ring in silver and gold by Claude Mazloum for the C. M. Collections of Geneva. There are also
170 *more precious versions of the jewel but in a limited series. Every piece is signed by the artist.*

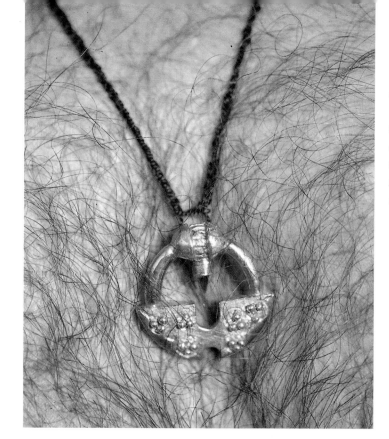

JEWELLERY FOR MEN

*S*uch a wide-ranging topic cannot be thoroughly covered in such limited space; let it suffice to say that it was originally men who wore jewellery, as a symbol of strength and power. Then over time and obeying the instincts of love, men offered women their most precious possessions. It certainly was a sign of gratitude for the marvellous gifts they received in turn but also an outward sign that the woman belonged to man, a clan, a tribe.

Women today have preserved these gifts to adorn themselves, using them as a vehicle of seduction. But there as also been a gradual return to beginnings, here as in other areas, so it is more and more common to see a woman offering a man a piece of jewellery.
This choice might be determined by the difficulty of fiding a gift a man would like or perhaps, here too, it is a personal message of love.

171

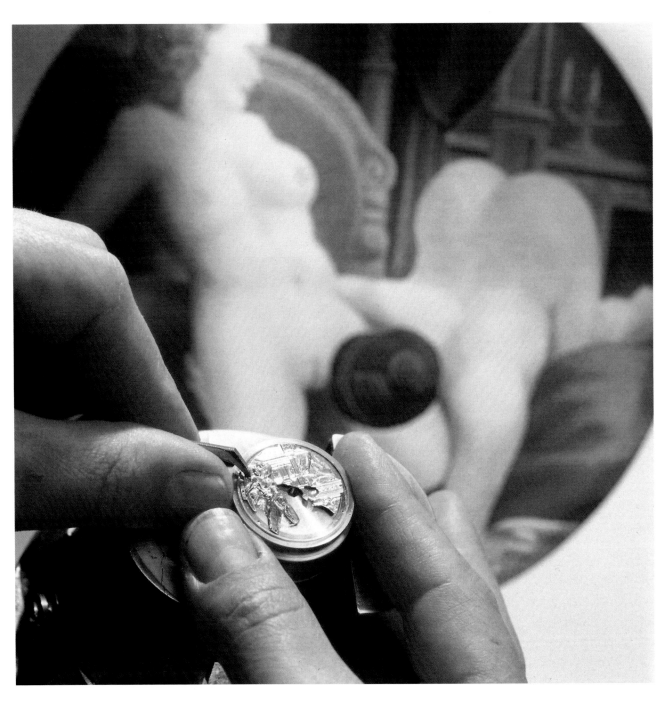

To the woman I love: "I dream of lying for one moment between your arms –
and that time stopped for all eternity."

"LIBERTINE WATCHES"

How can a watch, a simple instrument for the measurement of time, have any type of erotic claim whatsoever? Let's answer this question with another question: can you think of anything more exciting than setting the time for a love tryst? Nor can a date take place without the help of a watch… better yet if it is "libertine".

Indispensable as it is, this object has, over the course of time, made its way up in the world to reach the pinnacle as a jewel. The possibility of blending time and art in the same object has given rise to a panoply of new creative possibilities. It has allowed artisans to vary their expressive reach.

Today, this object that everyone wears not only measures time. It also measures its owner's wealth, elegance or libido. The watch denotes power and confirms personality. From this comes the ability it has in common with jewellery, to bear a message. That was the origin of the idea, born many centuries ago, of creating an erotic style which is essentially representational, primarily for libertines.

HUBLOT EROTIQUE, to make the time more racy

Do you know anyone uninterested in eroticism? Then why not add some spice to the passing time?

The Hublot, one of today's most successful bracelet watches, has a cover over the dial. On the outside you can place a monogram, a seal or even a dedication engraved in the gold.

The inside face contains a hand-painted miniature, a tiny, delightfully titillating scene in the manner of a Kamasutra rendezvous, an amused gibe at rigid conventionality.

The charming homage to eroticism is seductive by itself, with the elegant gold watch case surprisingly combined with a black India rubber watchband.

Dedicated to those who appreciate fine watches, the Hublot erotique will also be admired by those who appreciate the delectable things in life combined with a touch of wry humour.

We like to think that it will be given and worm with a smile as naughty as the secret little painting inside.

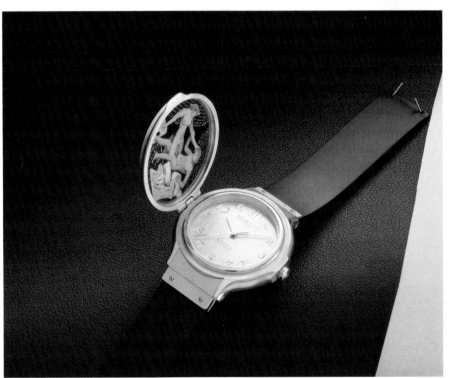

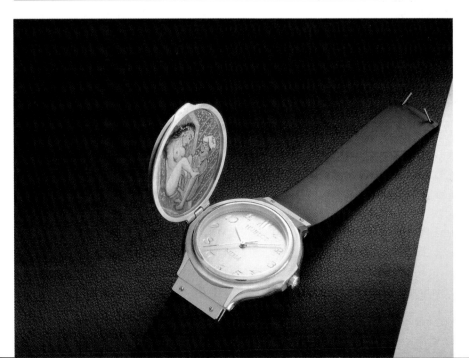

"Evol" watch. The name is nothing more than the word "Love" read backwards in the mirror of desire. It was born of an idea by Cellina Barth who asked painter Romano Vitali to create a design for this particular model (limited series).

EROTIC WATCHES – one of a kind

C.M. COLLECTIONS recently developed an exclusive system that allows every owner and not only artists, to freely express their creative bent on a watch dial, treating it like a sheet of paper or a canvas.

This new procedure turns each and every watch into a one of a kind signed piece, as libertine as you could wish, without any limitation. An occasion for collectors not to be missed. The cost can be contained by choosing watch case materials with care so that the value of the watch depends entirely on the talent of the artist whose work is on the dial.

The central motif stands out against the purity of the design and the simplicity of the case in watches that are often libertine and always of great charm.

175

*One-of-a-kind piece designed by sculptor Hubert
Minnebo and made by C.M. Collections, Geneva.*

*Got a second?
This simple, everyday question will have a double
meaning for the owners of this watch that its designer,
Catherine, has dubbed "Second". The dial is a
miniature oil painting. Made by C.M. Collections,
Geneva.*

*"Lovers" and "Encounter" are the titles of two watches created by the Roman painter Enrico Pinto. One-of-a-kind
pieces by C. M. Collections, Geneva.*

FROM RIMBAUD TO BLANCPAIN: reinvented Love

If, as Arthur Rimbaud wrote, "Love should be reinvented", the same thing is true of the contemporary libertine watch. No sooner said than done.

After its six main pieces – the ultra-flat watch, the moon-phase watch, the perpetual calendar, the split-second chronograph, the tourbillion, the minute repeater – Blancpain presents the world's first libertine minute repeater bracelet watch.

The minute repeater is an authentic masterpiece of traditional art. It is the only watch in the world that tells you the time without looking at the dial, the outcome of our exceptional in-depth knowledge of the temper of metals and a perfect command of accoustics and dynamics.

The invention of the world's first mechanical memory allows this timepiece to sound out the hours, quarter hours and minutes upon request.

Our skilled watchmakers have written a new page of history, completing this masterpiece with the addition of robots.

The small animated dials, engraved or enamelled, appear in all their splendour on the watch case, protected by sapphire crystals.

The contribution of master watchmakers, enamellers and engravers has given life to a prestigious art object where the watch is paired with tiny mobile components.

This is truly a marvellous artistic rebirth, both modern and enchantingly traditional. The watches are one of a kind pieces since each libertine scene is different from all the others.

The rare, lucky owners will know how to appreciate these works of art.

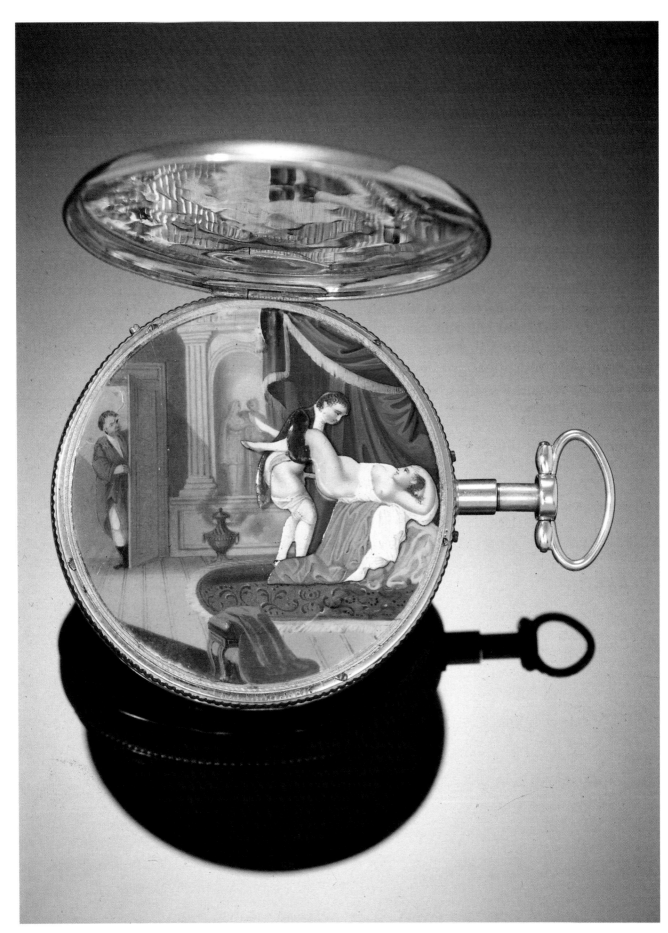

Quarter-hour repetition watch and music with erotic robots. The enamels of the libertine scene are very finely wrought. According to the legend, the main character is Napoleon I (ca. 1810). Photo curtsey

of Blancpain.

GALLERIES AND JEWELLERS

AUSTRALIA
- Contemporary Jewellery
 Gallery,
 162 A, Queen Street
 Woollahra 2025
 Sydney

AUSTRIA
- Galerie Gold Design,
 Führichgasse, 2
 1010 Wien
- Galerie El-Avantgarde,
 Altstadt, 2
 4020 Linz/Donau
- Galerie Slavik,
 Himmelpfortgasse, 17
 1030 Wien
- Galerie V & V,
 Bauernmarkt, 19
 1010 Wien
- Galerie Schullin & Söhne
 Herrengasse, 3 - 8010 Graz
 Kramergasse, 11
 9020 Klagenfurt
 Hauptstrasse, 187
 9210 Portschach
 Am Korso, 21 - 9220 Velden
 Gasthof Post - 6764 Lech

BELGIUM
- Badou,
 Place de l'Hôtel de Ville, 5
 5030 Gembloux
- Goussaert,
 Kortrijkstraat, 28
 8880 Tielt
- Galerij Muylaert,
 Nieuwstraat, 36
 9300 Aalst
- Garance,
 Rue de Namur, 99
 1000 Bruxelles
- Galerij Embryo,
 Naamsestraat, 49
 3000 Leuven

- Hertecant,
 Dumortierlaan, 71
 8300 Knokke-Heist
- Kimberley,
 Sint Kwintesberg, 19
 9000 Gent
- Huis de Koker,
 Marktstraat, 15
 9550 Herzele
- Pools,
 Ooststraat, 7
 8500 Roeselare
- Harmagedon,
 Sasboslaan, 7
 8510 Bellegem-Bos
- Maison de la Perle,
 Avenue Louise, 67
 1050 Bruxelles
- Nancy Aillery Jewel Design,
 Frans Versmissenlaan, 1/3
 2100 Deurne
- Sabine Herman,
 Rue Faider, 86
 1050 Bruxelles
- Créations Christiguey,
 Rue de la Gare, 69
 7322 Pommeroeul
- Galerie J.P. De Saedeleer,
 Place Cardinal Mercier, 17
 1300 Wavre
- Galerie Liehrmann,
 Boulevard Piercot, 4
 4000 Liège
- Jean-Pierre Laloux,
 Avenue Brugmann, 235
 1180 Bruxelles
- Galerij Groot-Begijnhof,
 Hoviusstraat, 6
 2800 Mechelen
- Kunstgalerij Kauterveerne,
 Mechelbaan, 163
 2861 Sint-Katelijne-Waver
- Galerie Neon,
 Rue Defacqz, 19
 1050 Bruxelles

- Jan Orye,
 Kapelstraat, 9
 3500 Hasselt
- Slaets N.V,
 De Keyserleistraat, 46/48
 2018 Antwerpen
- Castelein,
 Zuidzandstraat, 30
 8000 Brugge

BRAZIL
- Galerie Natan,
 Rua Visconde de Pirajà, 303 a
 309
 Rio de Janeiro

FRANCE
- Marie Zisswiller,
 61, rue d'Auteuil
 75016 Paris
- Galerie Hélène Poree,
 31, rue Daguerre
 75014 Paris
- Chéret aam,
 9, rue Madame
 75006 Paris
- Galerie Pylones,
 57, rue Saint-Louis-en-l'Ile
 75004 Paris
- Arthus Bertrand,
 6, place Saint-Germain des
 Prés
 75006 Paris
- Look 16,
 16, rue Vavin
 75006 Paris
- Galerie Franz Liszt
 7, place Franz Liszt
 75010 Paris
- Galerie Didier Clauss,
 26, rue Pastourelle
 75003 Paris
- Galerie Aurus,
 88, rue Quincampoix
 75003 Paris

- Galerie Naïla de Monbrison,
 6, rue de Bourgogne
 75007 Paris

GERMANY
- Galerie Gerhard,
 Goetheplatz, 6
 5920 Bad Berleburg
- Galerie Sonnichsen,
 Neuer Wall, 44
 2000 Hamburg 36
- Galerie Aurum
 Oppenheimer Landstraße, 42
 6000 Frankfurt
- Art Curial,
 Maximilian Straße, 10
 8000 München 2
- Galerie Cada,
 Maximilian Straße, 13
 8000 München
- Cardillac Schmuckgalerie,
 Waldstraße, 56
 Karlsruhe 1
- Knauth & Hagen Galerie,
 Thomas Mann Straße, 17
 5300 Bonn
- Galerie für Schmuck Hilde
 Leiss,
 Großer Burstah, 38
 2000 Hamburg
- Forum für Schmuck und
 Design E.V.,
 Lütticher Straße, 47
 5000 Köln 1
- Galerie Treykorn,
 Savignyplatz, 13
 1000 Berlin 12
- Galerie Biro,
 Ziebland Straße, 19
 80799 München
- Kurk Kubik
 Englerstraße, 32a
 69126 Heidelberg-Rohrbach
 Süd
- Die Werkstattgalerie,
 Heierottostraße, 1
 1000 Berlin 15
- Galerie Spektrum,
 Türhenstraße, 96
 8000 München

GREAT BRITAIN
- Gallery Hancocks,
 29, King Street
 Manchester M2 6AF
- Electrum Gallery,
 21, South Molton Street
 London W1 YIDD
- Contemporary Applied Arts,
 43, Earlham Street, Covent
 Garden
 London WC 2H 9LD
- Crafts Council Gallery,
 12, Waterloo Place
 Lower Regent Street
 London SW1 4AU

ITALY
- Bijoux & Pierres,
 Via della Penna, 59
 00186 Roma
- Galerie Fallani Best,
 Borgo Ognissanti, 15/R
 50123 Firenze
- Spazio Arte Johnson,
 Via Terraggio, 15
 20123 Milano
- Galerie Previtali,
 Via T. Tasso, 21
 24100 Bergamo
- Venice Design Gallery,
 Salizada San Samuele, San
 Marco
 30124 Venezia
- Galleria d'Arte Ellequadro,
 Vico Falamonica, 29R
 16123 Genova
- Il Gioiello per Panarea,
 Via Beppe Maria
 98050 Panarea (ME)
- Argentovivo,
 Via Gorani, 8
 20123 Milano
- Studio Vigato
 Via Ghilini, 30
 15100 Alessandria
- GR. 20 Studio
 Via Soncin, 27
 35100 Padova

- Galleria Schubert,
 Via Montenapoleone, 8
 20121 Milano
- Gian-Carlo Montebello,
 Corso Porta Vittoria, 14
 20122 Milano
- James Riviere,
 Via Brera, 2
 20121 Milano
- Aloisio,
 Via xMalabranca, 1
 05018 Orvieto (TR)

JAPAN
- Gallery Better Life,
 18-2; Akasaka 3-Chome,
 Minato-k
 Tokyo

NETHERLANDS
- Galerij Carin Delcourt van
 Krimpen,
 Eendrachtsweg, 59
 3012 Rotterdam
- Galerij Louise Smit
 Prinsengracht, 615
 1016 Ht Amsterdam

SPAIN
- Galerie Pedro Bueno,
 Bergamin, 3
 31002 Pamplona
- Galeria Hipotesi,
 Rambla de Catalunya, 105
 08008 Barcelona

SWEDEN
- Ib Wrange Smycken,
 Vastra Strandgatan, 7a
 75221 Uppsala

SWITZERLAND
- Schmuckgalerie Rudi Ritter,
 Marktgasse, 14
 9000 St. Gallen
- Schmuck Forum,
 Zollikerstraße, 12
 8008 Zürich

- Michèle Zeller,
 Kramgasse, 20
 3011 Bern 8
- Galerie Monnier
 1, Rue St. Maurice
 2001 Neuchâtel
- Fillner
 Buochserstraße, 15
 6370 Stans

USA
- Pennina Design,
 18 West Fourth Street
 Cincinnati Ohio
- Helen Drutt Gallery,
 1721, Walnut Street
 Philadelphia PA 19103
- Aaron Faber Gallery,
 666 Fifth Avenue

New York,
NY 10019
- Jewelers' werk Gallery,
 2000 Pennsylvania Avenue-
 Northwest
 Washington DC 20006
- Sheila Nussbaum,
 358 Milburn Avenue
 NJ07041 Milburn

MUSEUMS

AUSTRIA
– Österreichisches Museum für
Angewandte Kunst,
Stubenring, 5
1010 Wien

BELGIUM
– Diamantmuseum,
Oude Steenweg, 13a
2280 Grobbendonk
– Diamantmuseum Antwerpen,
Lange Herentalsestraat, 31-33
2018 Antwerpen
– Museum voor Sierkunst van
de Stad Gent,
Jan Breydelstraat, 5
9000 Gent

FRANCE
– Musée du Luxembourg,
19, rue de Vaugirard
75015 Paris
– Musée des Arts Décoratifs,
107, rue de Rivoli
75001 Paris
– Bibliothèque Forney,
1, rue du Figuier
75004 Paris
– Musée d'Art Moderne et d'Art
Contemporain,
Promenade des Arts
06300 Nice

GERMANY
– Deutsches Goldschmiedehaus,
Altstadter Markt, 6
D-63450 Hanau
– Schmuckmuseum Pforzheim,
Jahnstraße, 42
7530 Pforzheim
– Städtisches Museum,
Im Prediger
7070 Schwäbish Gmünd
– Deutsches Edelsteinmuseum
Idar-Oberstein,
Mainzer Straße, 34
55713 Idar-Oberstein, 1

– Museum Idar-Oberstein,
Hauptstraße, 436
6580 Idar-Oberstein, 1
– Museum für Kunst und
Gewerbe,
Steintorplatz, 1
2000 Hamburg
– Collegium Cadora,
Schumannstraße, 15
6200 Wiesbaden
– Museum für Gestaltung,
Bauhausarchiv
Klengelhoferstraße, 14
1000 Berlin
– Wuppertaler Uhrenmuseum,
Poststraße, 11
5600 Wuppertal, 1

GREAT BRITAIN
– Goldsmiths' hall,
Forster Lane
London Ec 2v 6 bn

NETHERLANDS
– Stedelijk Museum,
Paulus Porterstraat, 13
1071 Hv Amsterdam
– Museum Het Kruithuis,
Citadellaan, 7
5211 XA's-Hertogenbosch

SPAIN
– Museo de Minerales,
Rios Rosas, 23
28000 Madrid
– Museo Nacional de Incisiones,
Alcalà, 13
28000 Madrid
– Museo Nacional de Artes
Decorativas,
Montalban, 12
28000 Madrid

SWITZERLAND
– Museum Bellerive,
Höschgasse, 3
8034 Zürich

– Musée des Arts Décoratifs,
Avenue Villamont, 4
1005 Lausanne
– Musée de l'Emaillerie et de
l'Horlogerie,
Route de Malagnou, 15
Genève
– Gewerbemuseum/Museum
für Gestaltung,
Spalenvorstadt, 2
4051 Basel
– Museum für Gestaltung,
Ausstellungstrasse, 61
8005 Zurich

USA
– The American Craft Museum,
40 West 53rd Street
New York - NY 10019
– Craft and Folk Art Museum,
5814 Wilshire Boulevard
90036 Los Angeles
– Cooper Hewitt Museum of
Decorative Arts & Design,
Smithsonian Institution
9e, 90th Street
New York - NY 10019
– Metropolitan Museum of Art,
5th Avenue, 82 Street
New York - NY 10019

*We must also mention the world's
most important museums that
display collections of jewels and
precious stones: the Louvre
Museum in Paris, the British
Museum in London, the Victoria
and Albert Museum in London,
the Topkapi Museum in Istambul,
the National Museum of Florence,
the Natural History Museum of
Paris, the Metropolitan Museum
of New York, the Museum of
Natural History of New York, the
Smithsonian Institution of
Washington, the Kremlin Museum
in Moscow and the Gold Museum
in Bogotà.*

TRADE PRESS

ARGENTINA
– El Orfebre, Buenos Aires

AUSTRALIA
– Jewellery World, Eastwood

AUSTRIA
– Uhren-Juwelen, Wien

BELGIUM
– Antwerp Facets, Antwerpen
– Antwerp Gems, Antwerpen
– Arts, Antiques, Auctions, Bruxelles
– Bijoux, Bruxelles
– Diamant, Antwerpen
– Jedifa Magazine, Bruxelles
– Kompass Diamonds, Antwerpen
– Lithorama, Bruxelles
– Technica, Bruxelles

BRAZIL
– Gemas Joias Relogios, São Paulo

CANADA
– Canadian Jeweller, Toronto
– Jewellery World, Toronto

FINLAND
– Golde, Espoo
– Kelloseppa, Espoo

FRANCE
– Galeries Magazine, Paris
– La France Horlogère, Paris
– La Revue des montres, Paris
– Le Bijoutier, Paris
– Montres Magazine, Paris
– Offrir, Paris
– Orion, Paris

GERMANY
– Art Aurea, Ulm
– Atelier, Köln
– Der Fachanzeiger, Konigsbach-Stein
– Fz, Konigsbach-Stein
– Goldschmiede und Uhrmacherzeitung, Stuttgart
– Gold + Silber-Uhren + Schmuck, Leinfelden-Echterdingen
– G.Z. European Jeweler, Stuttgart
– Schmuck und Uhren Magazin, Ulm
– Uhren Juwelen Schmuck, Bielfeld
– Zeitschrift der Deutschen Gemmologischen Gesellschaft, Idar-Oberstein

GREAT BRITAIN
– British Jeweller, Peterborough
– Contemporary Art, Southampton
– Diamond International, London
– Diamantaire, London
– Grey Suit, Wales
– Jewellery International, London
– Retail Jeweller, London

HONG KONG
– Asia Precious, Hong Kong
– China Precious, Hong Kong
– China Review, Hong Kong
– Hong-Kong Jewellery Collection, Hong Kong
– Hong-Kong Jewellery, Kowloon
– Jewellery News Asia, Hong Kong
– Jewellery Review, Wanchai

INDIA
– Diamond World, Jaipur
– Gems & Jewellery, Bombay
– Journal of Gem Industry, Jaipur
– Watch Market Review, Bombay

ISRAEL
– Diamond World Review, Ramat Gan
– Hayahalom, Ramat Gan
– Israel Diamonds and Precious Stones, Ramat Gan
– Mazal U'Bracha/Adi'or, Herzilia

ITALY
– Argento, Roma
– Il Mondo dei Gioielli, Arese (MI)
– Italia Orafa, Milano
– 18 Karati, Milano
– La Clessidra, Roma
– L'Orologio, Roma
– Orafo Italiano, Milano
– Orologi, Roma
– Orologi e non solo, Roma
– Proposte Top, Alessandria
– Risk, Milano
– The Market, Milano
– Valenza Gioielli, Valenza (AL)
– Vogue Gioiello, Milano

JAPAN
– Appeal, Tokyo
– Les Joyaux, Tokyo
– Nikkei Jewellery, Tokyo

KOREA
– Korea Watch and Jewellery Journal, Seoul
– Precious Metals and Jewellery, Seoul

LEBANON
- Fairuz, Beyrouth
- Jamalouki - Votre Beauté, Beyrouth
- La revue du Liban, Beyrouth
- Le Réveil, Beyrouth
- L'Orient - Le Jour, Beyrouth
- Monday Morning, Beyrouth
- Nouveau Magazine, Beyrouth
- Prestige, Beyrouth

MEXICO
- Nuestra Joya, Guadalajara

NETHERLANDS
- Edelmetaal, Voorburg
- Euro Juwelier, Warmand
- Jewel, Rotterdam

NEW ZEALAND
- Art New Zealand, Auckland

NORWAY
- Gullsmedkunst, Oslo

PERU
- Silver Crafts Time, Lima

POLAND
- Exit, Warszawa

PORTUGAL
- Quilate, Porto

SINGAPORE
- Asian Jewellery, Singapore

SLOVAKIA
- Profil, Bratislava

SOUTH AFRICA
- Diamonds News & S.A.Jeweller, Randburg - Johannesburg

SPAIN
- Arte Galicia, Ferrol
- Arte y Joya, Barcelona
- Cronos, Barcelona
- Gold & Time, Madrid
- Golden Prestige, Barcelona
- Lapiz, Madrid
- Oro y Hora, Barcelona

SWEDEN
- Guldsmedstiging, Stockholm

SWITZERLAND
- Europa Star, Genève
- Journal Suisse des HBJO, Lausanne

- Montres Passion, Lausanne
- Revue FH, Bienne

TAHITI
- La Dépêche de Tahiti, Papeete

TAIWAN
- Jewellery Circle's Magazine, Taipei

THAILAND
- Gems & Jewellery, Bangkok
- Jewelsiam, Bangkok
- Thailand Jewellery Review, Bangkok
- The Facet, Bangkok

USA
- Artforum, New York
- Colored Stone, San Diego
- Diamond Insight, New York
- Facets, New York
- Gems Gemmology, Santa Monica
- Jeweller's Purchasing Journal, Memphis
- Lapidary Journal, Devon
- Modern Jeweler, Shawnee Mission
- National Jeweler, New York
- New-York Diamonds, New York

THE WORLD'S FINEST CREATORS

PHOTOGRAPHIC CREDITS

Alessandra ALIPERTI 166

Paul de BACKER 70, 71, 125, 126, 127, 128, 176

Nelly BARIAND 27

BARSAMIAN/MINSART 4, 62, 63, 68

Cellina BARTH 175

Photos BLANCPAIN 177

Paolo BOCCARDI 31, 155

Louise H. BORGEN 162

Carrie BRANOVAN 77

Woo-Hyun CHOI cover

Lina FANOURAKIS 156, 157

Marcello FAUSTINI 82, 83

FOTO 2000, 170

A. GÄBLER, 72

William GERMANI 106

Alberto GIORGI 118, 119, 121

Lugder GRUNWALD 88

H.P. HOFFMAN 97

Sungmin HONG 165

Studio JANJAC 107

Vincent JAUMIN 76

Photos JOOP! 48, 171

Imithias KALEEL 138

Shuki KOOK 163

Hella KRAUSS 34-45

Thomas KRULL 167

Wolfgang KUNZ 160, 161

Cesare GUALDONI 178

Photos HUBLOT 174

LEHNERT & LANDROCK 152

LICHBLICK FOTO-DESIGN 93, 96

LORNE LIESENFELD 90, 91, 94, 95, 98, 99

André LOUIS 65, 66, 67, 69, 73

Rino MONTINI 109, 130, 131

Simonne MUYLAERT-HOFMAN 133, 134, 135

Beatrice NORMAND 176

Daniel Van NUFFEL 164

Stefan PAULI 28, 29

Erwin PAULY 140, 144, 145, 146, 147

PHOTOCHROM 2, 3, 4, 8, 15, 16, 17, 18, 19, 20, 21, 22, 23, Back-cover

Sergio PUCCI 112, 113, 116, 117, 176

Erica VAN PELT 148, 149

Severine QUEYRAS 136, 137, 171

Lee Sang RIMP 104

Morgan ROCKHILL 32

Anna-Maria ROSATI 100, 101

Ph. ROLLEE 30

Antonio ROTUNDO, 6, 33, 108, 155

Danilo RUSSO 80

Massimiliano RUTA, 84, 85, 86, 87

Elias SAYEGH 75

Jeff SLACK 79

Massimo SORMONTA 74

Gerd SPRENG 102, 103, 158, 159

Fred THOMAS cover, 50, 52, 53, 55, 56, 57, 58, 59, 60, 61

Felix TIRRY 132, 133

Raphael VENDOME, 10, 24, 26

Ricardo De VICO 122, 123

David ZANARDI 81